The Enchanted Forest

To David — *December 2013*

The Enchanted Forest

Memories of Maryland's Storybook Park

Martha Anne Clark

Janet Kusterer

Linda Harrison Gardner

Janet Kusterer & Martha Anne Clark

Charleston · London

THE
History
PRESS

Published by The History Press
Charleston, SC 29403
www.historypress.net

Cover: Photos courtesy of Linda Harrison Gardner. Original art by Monica McNew-Metzger.

First published 2013

Manufactured in the United States

ISBN 978.1.62619.139.6

Library of Congress CIP data applied for.

This book is dedicated to our families and friends, whose support encouraged us as we accomplished our goal, and to all of the people who have kept the memory of the Enchanted Forest in their hearts for so many years, and who have so graciously shared their stories with us.

Contents

Acknowledgements

To know the Enchanted Forest was to love it, and a lot of people still do. We appreciate the many people who were willing—and eager—to share their wonderful memories of the Park with us. Our deepest gratitude goes to Linda Harrison Gardner, a daughter of Geraldine and Howard Harrison Jr., who assisted us in every way, from storytelling to providing us with many of the incredible vintage photographs we are delighted to share. Another special thank you goes to Norman Cavey, a longtime worker at the Park and a nephew of Joe and Bradley Selby, who ran the Park for many years. His stories made us laugh on many occasions, and we know that they are special memories that help make this book unique. Thanks to Rob Kusterer for his most valuable technical assistance and to Alice Webb for her professional expertise with our photographs. We also want to thank all of the hardworking volunteers who pitched in to move and restore many of the original Park attractions and settle them in their new home at Clark's Elioak Farm. And thanks to Mark Cline, whose wizardry with fiberglass continues to keep the figures fresh and vibrant, and to Monica McNew-Metzger for creating such special artwork. We are so happy to contribute to saving the memories, along with saving the Three Little Pigs and the Pumpkin Coach.

An Idea Is Born

Howard Harrison Sr. was the perfect grandfather. He loved nothing better than to gather some of his thirteen grandchildren around him and tell them sweet and gentle fairy tales. They always clamored for more, and he was always glad to oblige. He wanted to make those fanciful stories come to life, not only for his grandchildren but also for children everywhere. And so the idea of the Enchanted Forest came to be. It was called "a storybook land of fairy tales come true"—and it was a giant step beyond simple stories told to a child perched rapt on his knee.

This was in the early 1950s, when the soldiers had come home from serving in World War II, married and started their families—the ubiquitous Baby Boomers. These families had sacrificed a lot during the war and welcomed opportunities for simple pleasures for the entire family, so Harrison knew he would have a large audience to draw from. The 1950s were a time when America's pop culture was exploding. People were buying their first cars, and according to Wikipedia, 77 percent of American families got their first television in that decade. Television brought *Howdy Doody*, *Ding Dong School*, *Captain Kangaroo* and *Romper Room* into the homes and lives of young children. *Romper Room* was originally broadcast from Baltimore, and Miss Nancy, the original star, visited the Park and signed autographs. These shows and the Park targeted the same audience—very young children and their parents.

Harrison wasn't the only one with this idea whose time had come. At the same time, a man named Walt Disney was hard at work creating a theme park on the West Coast. Disneyland—the country's first theme park—opened

Grace Harrison, Mrs. Howard Harrison, Sr. *Courtesy of Linda Harrison Gardner.*

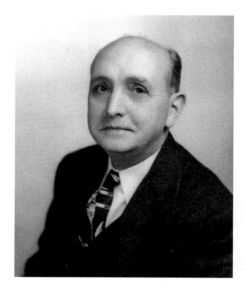

Howard Harrison Sr. ran a printing business in Baltimore before venturing into the storybook park business. *Courtesy of Linda Harrison Gardner.*

in July 1955, just a month before the Enchanted Forest opened on August 15. These parks were a big departure from other early amusement parks, like New York's Coney Island—the country's first amusement park—that relied on roller coasters and haunted houses. This one was meant to be, as the Enchanted Forest brochure stated, "fun for youngsters and the young at heart." The idea behind both Disneyland and the Enchanted Forest was to build a place where kids and adults could enjoy doing things together. Mr. Harrison never wanted any thrill rides in the Park. All the rides could be enjoyed by all ages. As for the name, in Grimm's fairy tales, the Enchanted Forest was the home of Hansel and Gretel.

Harrison owned and operated the A.W. Harrison & Son, Inc. Electrotypers and Stereotypers, a printing business located in Baltimore City where the Baltimore Convention Center is today. Harrison's son, Howard Harrison Jr.; his wife, Geraldine; and their four children were living in east Baltimore at the time the idea for the Park first took hold. Together, Senior and Junior Harrisons owned one of the new-style motels called the Belgian Village, located on Route 40 east, Pulaski Highway in Bradshaw, Maryland, just before Joppatowne. It was the first motor court on the East Coast, built in 1935. During World War II, soldiers from nearby Aberdeen

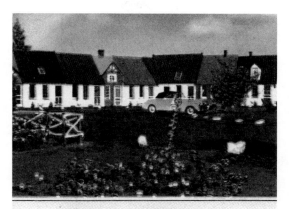

The Belgian Village was a themed motor hotel in eastern Baltimore County, which the Harrisons sold to finance the Enchanted Forest. *Courtesy of Linda Harrison Gardner.*

Proving Ground would stay there. The motel rooms were lined up on the first floor facing a courtyard, in the popular style, and the family lived in quarters on the second floor. In a way, the Belgian Village was a precursor of things to come with the Enchanted Forest, as each room had a different theme. Linda Harrison Gardner, one of Howard Jr.'s children, said, "The motel was really a wonderful place, too. One cabin was the Shoe Maker's House; another was the Candy Maker's House. It wasn't a motel like you would see today. It had character to it—it was really a beautiful place."

The motel advertised itself as making it unnecessary to cross the Atlantic to visit a Flemish village. It was a replica of a little Belgian town. Each little house contained one or two rooms with a private bath. Each of the unit's roofs was a different color. Meals were served in the Town Hall in the center

of the village. Gardner said, "My family ate every meal in the restaurant in the motel. That meant that all of us had to dress for dinner every night, and we always had to be on our best behavior." The Harrisons sold the motel to finance the Enchanted Forest. The motel was converted to a truck stop in 1962 and was torn down in 1987.

Chapter 1

Finding the Land

When the Harrisons decided to create their Park, the first step was to purchase land. They looked throughout the state of Maryland and settled on a plot on Route 40 west, Baltimore National Pike, in Ellicott City, Maryland, which was fourteen miles west of Baltimore and thirty-three miles from Washington, D.C. While Ellicott City is today regularly recognized in publications like *Money Magazine* as one of the finest places in America to live, due in part to being ideally located between Baltimore and Washington, D.C., back in the 1950s it was very rural and undeveloped. The property the Harrisons settled on was a dairy farm owned by William and Mamie Stern. The original dairy barn became Robin Hood's Barn in the Park, and the Sterns built a house for themselves on property next door to the Park.

The only commercial business nearby was the Gearhart Diner (later the Forest Diner across the street), where Howard Harrison Jr. ate lunch every day during the construction of the Park. The diner outlasted the Park, closing in 2012.

Harrison Sr. applied for financing at a bank, but the bank didn't share his vision, so he was forced to finance the project himself, with proceeds from the sale of the motel. It cost a quarter of a million dollars to prepare the Park for opening. He originally purchased twenty acres of forest surrounded by farmland. The Park eventually grew to fifty acres and then was reduced to thirty-two acres, with the rest becoming part of the Bethany Woods subdivision.

Charles Feaga was a dairy farmer in the 1950s in Howard County. Feaga said:

We'd all like to go back in time, but we can't. We didn't know the opportunities that were there until Jim Rouse came along and built Columbia. We welcomed the Enchanted Forest and thought it was a good idea. Howard County had about 15,000 people in it in the 1950s. [The population today approaches 300,000.] *It was mostly dairy farms.*

I graduated from high school in 1951, and I was in the first class that went to school for twelve years, so I never had anyone ahead of me moving up. I got a good education. Omar Jones, who went on to become county executive, was the principal the last two years I was at Ellicott City High. The teachers made themselves a part of the farming community. Miss Oldfield, who turned one hundred years old last summer, was my ninth-grade teacher. I still take her out to lunch once a year. She was strict but fair. The teachers knew that if we were late for school it was because we had work to do on the farm, not that we were goofing off. It was a different time. There were about thirty people in my graduating class, which was a lot. There were five high schools—Elkridge, Clarksville, Ellicott City, Lisbon and Harriet Tubman. Schools were segregated then, and Harriet Tubman was for the black children. We didn't lock the doors to our houses, and we left our keys in the car. We didn't think about crime. It was a very close-knit community—we all knew each other. We all behaved ourselves because our parents would find out from their friends if we did anything wrong. It was an easier time.

Theodore Mariani wrote about this time period in his monograph, *Impact of Columbia on the Growth and Development of Howard County, Maryland.* He conducted oral histories to find out what the county was like then. He wrote:

The perception of the respondents was unanimous in picturing Howard County as a sleepy, sparsely populated farm community. But if you were a farm family it was considered a great place to grow up, people were close knit and cared for one another…There was a sprinkling of development along Route 40, primarily commercial, and a few small residential subdivisions. The rest of the county was farmland, much of which was devoted to dairy farming…Prior to Columbia, Howard County culture revolved around the farm community; 4-H, Future Farmers of America, Maryland Young Farmers and the County Fair…In 1962 the only four lane road in Howard County was Route 1. The future Route I-95 was just a dotted line on a map.

Ed Lilley grew up in Howard County in the 1950s. He said:

For a time we lived on Valley Road, next to the Dunloggin Dairy. As kids we were afraid of the cows. Once in a while they would break through the fence and come into our yard—something about the grass being greener—and if it had rained recently there would be hoof prints in our yard. It was a different way of life. In good weather we were always outside, and I walked everywhere. I remember one time riding the school bus in elementary school and the road was slick and the bus driver was having difficulty getting up the hill. Well, he got half the kids in the bus to sit in the back for traction, and the other half to get out back and push—can you imagine the lawsuits something like that would bring on today?

Vickie Goeller grew up in a housing development just down the road from the Enchanted Forest. She said:

We lived in Valley Mede, behind the historic "Brick House on the Pike." They had a horse, and that horse bit my grandfather at least once a summer when he tried to play with it. We rode our bikes everywhere—even on Route 40. We'd leave our house in the morning and not return until dinner time. Back in those days, we defined where we were on Route 40 by the restaurants—there was Buell's, Goetz's, the Pig and Whistle, the Log Cabin and on St. John's Lane at Route 40 was Hardman's "Beauty Rest Cottages." When it snowed, the closest store we could get to was Brosenne's, just west of the Enchanted Forest. At that time there wasn't much to do in Howard County. There were no movie theaters. We did go to the swim club in the summer.

I went to St. John's Elementary School and had to walk out to Route 40 to catch the bus. The bus would ride west to Turf Valley, then back east to the school and in all that way the bus wouldn't get filled with children. There were not a lot of people for me to play with. There were a lot fewer people here then.

Gardner remembered what it was like when the family first saw the property. She said:

We have always been a very close family, but when our father brought us out here we felt like he was moving us to nowhere. It was a long drive to get there, and the first time we saw the property, it was twenty acres covered

Geraldine Harrison, Mrs. Howard
Harrison Jr., said that life for her
family was like living in a fish bowl,
but they all loved it. *Courtesy of
Linda Harrison Gardner.*

Howard Harrison Jr. was
rarely seen without one of his
trademark bowties. *Courtesy of
Linda Harrison Gardner.*

*in deep woods, and the only buildings were a tarpaper-covered dwelling,
chicken coops and pigpens. It had been a dairy farm. The closest shopping
area was Edmondson Village* [a shopping center more than ten
miles east, toward Baltimore]. *To the west, Route 40 ended about a*

mile up the road, where the Turf Valley Resort Hotel is now. To go farther west you had to go over to Frederick Road. Our parents wanted to send us to Catholic school, so we went to Baltimore for that too. After my parents sold the Belgian Village, and during construction of the Park, we lived in the Northwood area of Baltimore for a year and a half—the only time growing up we lived in an actual neighborhood. When we moved to our house in the Enchanted Forest in 1954 I was eight years old, my brother Bruce was five, my sister Barbara was eleven and my older brother Buddy was fourteen.

According to Norman Cavey, who worked at the Enchanted Forest from 1961 through 1977 (except for a stint in the army):

Sometime in 1954, my uncle, Joe Selby, found out that the Enchanted Forest was being built and went to see Mr. Harrison and asked him what he planned to do with the trees that needed to be removed. He was in the pallet-building business at the time, so he could use the trees for lumber. Mr. Harrison hired Uncle Joe to be in charge of a crew of men who were removing trees to make room for the parking lots and the areas where the Castle and houses would go and to thin out the woods for paths and things like that. Mr. Harrison, whose time was taken up with meetings and the design of the Enchanted Forest, noticed how well Joe could manage a group of men and get the work done. So he asked Joe if he would like to be the manager of the crew, and Joe said yes.

Thus began a great relationship between the two families. Four generations of the Harrison family owned, managed and worked at the Park, and as Norm Cavey relates, for his family it was the same. Cavey said, "It was a family affair—four generations of my family worked there over the years. My uncle Joe Selby was the first manager of the Park, while his brother Bradley was the second. Their wives, their kids, my mother and about ten cousins worked in the Park, so we always jokingly said that one family owned the Enchanted Forest and another family ran it."

Chapter 2
Building the Park

Howard Adler, of Adler Display Studio, Inc., was chosen by Mr. Harrison Sr. to design and create the characters and buildings for the Enchanted Forest. Adler was the artist who created the popular animated Christmas window displays at the department stores in downtown Baltimore. He first met with the senior Harrison to discuss the project in January 1955—a mere seven months before the Park was due to open. The plan was to turn two-dimensional storybook illustrations into three-dimensional figures. Adler and his team of twenty artisans were given free rein to develop the figures. They started with frames of wood and chicken wire and then built them up with layers of papier-mâché. The figures were then covered with Celastic, a treated fabric that dries hard and strong, providing a weatherproof covering. Then the figure was finished with oil-based paints. They weren't tied to specific looks for the figures, and so Adler creatively added such touches as a slide in the Old Woman's Shoe and shoelaces made out of fire hoses.

At first, the figures were created by Howard Adler's team in his Baltimore studio on West Franklin Street. A work barn next to Robin Hood's Barn was the staging area for many of the attractions. Gardner said, "We couldn't wait to get home from school and see what was going on. I'm sure we drove the workers crazy but they were always very nice to us. They laid out the paths they wanted with crush and run, so they knew where to put the buildings." All of the Enchanted Forest buildings were made on site, which was quite a challenge for all concerned.

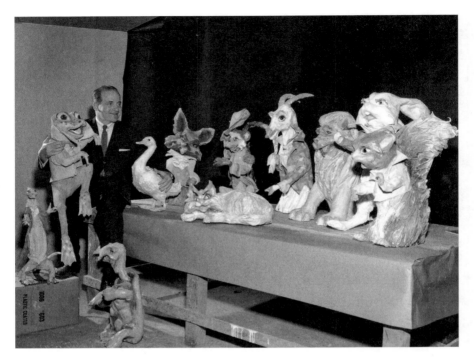

Howard Adler was very proud of the array of fanciful creatures he created for the Enchanted Forest. *Courtesy of Linda Harrison Gardner.*

Adler sketched his ideas for the buildings, and the Baltimore architecture firm of Bonnett & Brand was then hired to devise structurally sound blueprints. Subcontractors built the buildings on site, which were then completed and decorated by Adler and his staff. One particular challenge was the Crooked Man's House. A carpenter hired to complete the job walked off, saying it was impossible to build. It was eventually completed in spite of the difficulty of finding carpenters who could build a house requiring them to go against all of their training.

As time went on, Adler wasn't the only one creating attractions at the Park. Cavey said:

> *Uncle Joe was a very creative person. He loved to draw and was very good with design. Several attractions were built to his designs. These include The Chapel in the Woods, built in the late 1950s–early 1960s; The Lighthouse at the lake, built in the early 1960s; Cinderella's Castle, built in 1967; Ali Baba's Magic Mountain, built in 1971; Huck Finn's*

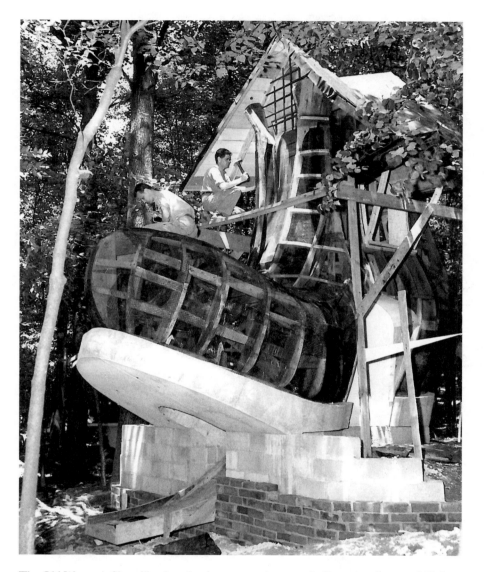

The Old Woman's Shoe, like the other large attractions, was built on site. *Courtesy of Linda Harrison Gardner.*

Fishing Hole, built in 1977. I know for sure that Cinderella's Castle was built with plans we saw on a napkin that Uncle Joe had with him all the time. It was hard to build because he had to tell people the way he wanted it to be—he would draw on paper the part of what was being built that day or week. Keep in mind that Howard County permits were not all that

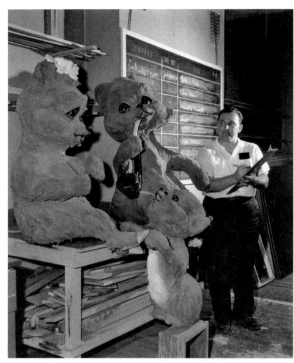

Left: While the larger structures were built on site, smaller figures like the Three Bears were created in Adler's studio. *Courtesy of Linda Harrison Gardner.*

Below: Workers used the old dairy barn as a maintenance area to build such features as the dragon. *Courtesy of Linda Harrison Gardner.*

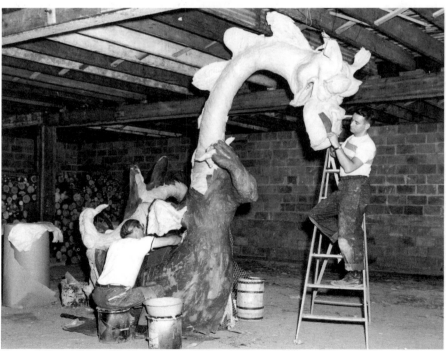

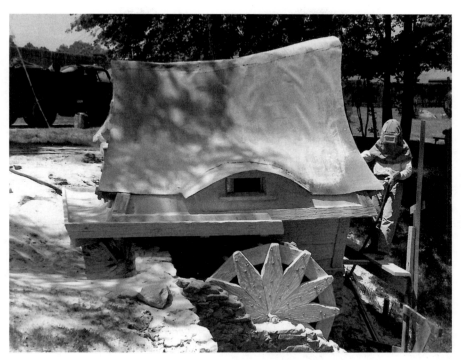

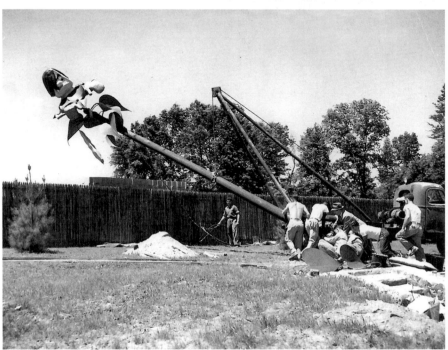

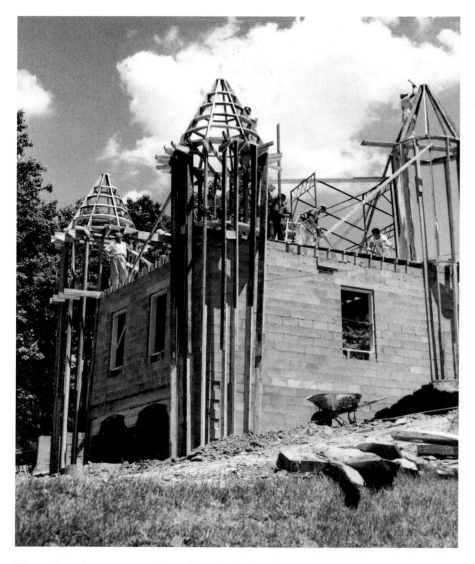

The castle at the entrance to the park required a lot of manpower to build. *Courtesy of Linda Harrison Gardner.*

Previous page, top: A worker wears protective headgear while welding the Merry Miller's House. *Courtesy of Linda Harrison Gardner.*

Previous page, bottom: Raising Jack's Beanstalk wasn't easy. It was made out of a telephone pole. *Courtesy of Linda Harrison Gardner.*

Here the plans for the Gingerbread House under construction are being reviewed by Howard Adler and an assistant. *Courtesy of Linda Harrison Gardner.*

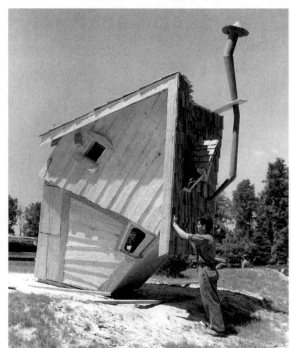

Workers had a hard time believing that the Crooked House could stand, but it did—for decades. *Courtesy of Linda Harrison Gardner.*

rigid at the time. I remember being told that when the Mountain was being built the inspector came out to look and he told them that it looked okay to him, but what did he know about building a mountain. Well, you couldn't get away with that today.

It is amazing in retrospect to comprehend the amount of freedom the Harrisons gave to both Howard Adler and Joe Selby. Possibly understandable in Adler's case, since he was a trained professional, but Joe Selby learned on the job—remember that he was in the pallet-building business when he first met with the Harrisons.

Cavey went on to say:

Uncle Joe borrowed a fairy tale book from me way back in the late 1950s, and he would read the stories over and over getting ideas for the Park. He used to have a book that he would draw in all the different ideas he would come up with. Unfortunately, it burned up in the house fire that killed Uncle Joe and Aunt Betty on March 7, 1981.

When I was a kid, long before I ever started working at the Enchanted Forest, my mother and I were visiting Aunt Betty at her home when Uncle Joe came home for lunch. During the time the Park was closed, Uncle Joe and Uncle Bradley (who lived right up the road) would come home for lunch. They were both living only a few miles from the Park on Old Frederick Road. On this particular afternoon, we were in the living room and Uncle Joe was in the kitchen eating lunch. The kitchen table was one of those types that had a laminate top and a chrome ring around it. We've all seen this type of table in pictures of family life in the 1950s. Well when Uncle Joe left to go back to work Aunt Betty came out into the living room and said to us, "Come in here and look at this." When we got to the kitchen table we saw a drawing of the Chapel in the Woods drawn on the table top. This is what Uncle Joe did all the time when he had an idea or a project he was working on. The picture looked exactly like what we saw that spring in the Park.

The figures in the Park were made out of a material called Celastic. This material was canvas-like, with a powder-like material embedded in it and it came in a large roll. We would tear off a section of whatever size we needed and place it in a solution of acetone. The acetone would make the canvas-like material like wet paper and when you applied it to what you were making and smoothed it out, the powder would become a paste and smooth over the seams so that they became invisible, and then it would get

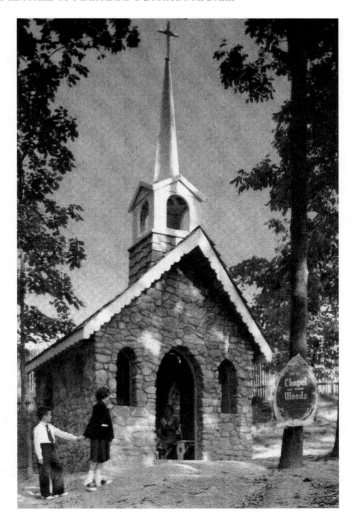

This postcard of the Chapel in the Woods also shows Bruce and Linda Harrison in their parochial school uniforms. *Courtesy of Linda Harrison Gardner.*

hard. This was usually applied over chicken wire or wire lathe formed into a figure. These figures were very light in weight and could be carried off or broken up very easily. It wasn't until 1966–67 that fiberglass was used at the Enchanted Forest. After that all figures were made of fiberglass and painted. Eventually we put cement or bricks in the ones that seemed to be stolen more than the others to keep them from being too easy to carry away.

In today's world nothing like this is portable. Figures on display are not only heavy, but they are also usually secured in place with bolts that require special tools to undo. It really was a different world.

Cavey continued:

The first thing to be made of fiberglass was the Pumpkin Coach. One morning Uncle Joe came into the maintenance barn and told James Boszell and me to sweep the floor. After the floor was swept Uncle Joe took a large crayon and drew the side of one of the mice on the floor between the measurements Uncle Bradley had marked. These marks helped Uncle Joe keep the right length of the mouse carts we would build. After he got the look he was going for, Uncle Bradley began to heat rebar with a torch, and bend it to the shape shown on the floor. This was then welded to the side of the cart, and additional pieces were added to give them width. We then covered that with wire lathe and applied a very thin layer of cement. We did this same process for all of the mice and the coach. Then we wondered if the tractor we used under the first pair of mice would be able to pull the other two pairs of mice and the coach full of people up the hill behind the Gingerbread House and next to the moat by the Castle. So, we hooked everything up with their first coat of cement and tried it. The tractor had a little trouble but not much, but we knew if we added the remaining coats of cement and the people in the coach the tractor would have a pretty hard time climbing that hill.

So, that was when fiberglass came to the Enchanted Forest. Since fiberglass was a new product at the time we had no way of knowing the right way to use it. We hired a fiberglass company to coat the Pumpkin Coach while we watched. From that point on we did all of the fiberglassing the Enchanted Forest needed ourselves.

James Boszell was a very close friend to the Selby family. As a child there were many nights he stayed over at the Selby household. He went to the same schools as Uncle Joe and Uncle Bradley—West Friendship Elementary and then Lisbon High. James was not only friends with Joe and Bradley but also Uncle Johnny—another brother who only worked at the Park for a very short time. Before James worked at the Park full-time he had a variety of jobs, one of which helped the Park a lot. James once held a job with Uncle Johnny as a plasterer, plastering the walls of new houses. This is what most houses had before drywall. He also was good at working with cement. Since most of the attractions were made of concrete this was very handy.

Almost all of the walls on the rabbit hole were finished by James, which was just one of the things he worked on. Repairing and maintaining the buildings and attractions was a constant job and things like Mount Vesuvius needed to be patched year after year. The movement of freezing

and thawing that Maryland weather put these things through cracked them and knocked off pieces of concrete that needed to be replaced all the time. This not only kept James busy, but also all of the full-time employees. So many people would ask me what we did in the winter time when everything was closed. Well, you don't just lock the doors at the end of the season and unlock at the beginning of the season. You take thousands of people just touching the same place all season long and you not only remove all the paint but sometimes just about wear a hole in it.

It is easy to ignore the amount of maintenance required to keep the Park attractive and running smoothly. Even when Bradley Shelby was holding things together with duct tape and a smile, he never let visitors know there might be a problem.

Cavey said:

James Boszell and I helped build the Mexican Sombrero. This was basically a decorative shelter for the donkey that was there for the people

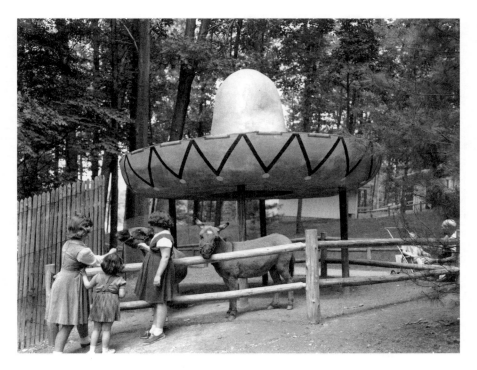

The Mexican Sombrero offered shade for the live burros available for petting. *Courtesy of Linda Harrison Gardner.*

to see and pet. It was located across from Willie the Whale. Again, this was one of the drawings that were in Uncle Joe's book. Uncle Bradley welded the rebar together to form the hat and James and I installed the wire lathe and I mixed the cement and James applied it. After the cement was completed, James and I painted the main color and Uncle Joe painted the design on it.

I also really believe that one of the reasons the Enchanted Forest buildings weren't that tall is that Uncle Joe and Uncle Bradley didn't like to climb high; another reason being cost. It didn't bother James at all and he was the one who most of the time was up in the air. Even for things like changing the flags on the turrets of Cinderella's Castle you had to climb to the base of each turret to get to the rope connected to the flag. The upper turrets were probably forty feet or more off the ground. To change the light on the top of the Lighthouse again you were forty feet or more off the ground. I think the Lighthouse would have been taller if Uncle Joe or Uncle Bradley could have worked higher off the ground.

Chapter 3

Opening the Park

The Publicity Department of Stanley L. Cahn, Co, Sales-Marketing-Advertising, issued a news release in 1955 just before the Park opened, describing the Park. It said, in part:

> *In this 20-acre park, artists, architects, and builders with unbounded imagination have recreated a wonderland of Mother Goose rhymes and fairy tales that have enchanted the whole world for generations.*
>
> *The Enchanted Forest had its beginning in the spring of 1954 when Howard E. Harrison and his son, Howard, Jr. searched the entire state of Maryland for the most appropriate and centrally located piece of land. They were seeking a site that could figuratively take visitors back to the Black Forest country where so many story-book legends originated.*
>
> *After months of combing the countryside, their choice became a 20-acre farm bordering the Little Patuxent River, near Ellicott City, on the new dual highway, (Route 40) to Frederick.*
>
> *The Harrisons selected a well-nigh perfect site, with a rolling wooded section, opening on a clearing where a pond is in the center of a greensward, and a glen is cut by a stream that forms an island above the pond. Alongside of the Forest are a pasture and two large red barns, with woods closing in at the side and rear. A sizeable pasture has been cleared and paved for parking for over 250 cars.*
>
> *The idea of the Enchanted Forest was still only a gleam in the minds of father and son until they met up with Howard Adler, of Adler Display*

Studios in Baltimore…the first rough drafts were on paper within only a few weeks of their first meeting. But many more weeks and months were needed to create and plan the Enchanted Forest and its array of characters and structures.

Then the imaginative ideas of timeless fairy tales and fun-loving artists had to be "nailed down." To make the forest structures unusually attractive, yet durable and usable, the experience and skill of an imaginative yet practical architect was required.

Bonnett & Brandt, Baltimore architects and engineers, were selected for the project. They spent many weeks developing construction plans, selecting materials, checking the site for every detail, including how much water would be needed to make the Merry Miller's mill-wheel go round at the proper speed. Charles Brandt had the task of bridging the gap between fantasy and reality. Since there was so little precedent to guide him, many days of extra time were required to study and experiment with details. One of these was the problem of the angle of the Crooked House, which looks as if it will fall right on top of you, yet is so strongly built and carefully placed that it can withstand tons of gravitational pull.

Another serious problem was to get carpenters and brick-layers in the spirit of the Forest and actually build the story-book structures out of line, in odd tangents and with strange materials. All sorts of difficulties had to be met in designing, planning and construction, so both Adler and Brandt will surely heave sighs of relief when the Enchanted Forest opens its gates in early August.

While the architects and builders were at work on the site, Mr. Adler's staff of 10 imaginative display artists in his studio on West Franklin Street worked around the clock, creating and building the unusual Enchanted Forest denizens. Rare indeed is the artist who can have a full rein in creating the legends of childhood under ideal surroundings. And it goes without saying that artist Adler and architect Brandt took advantage of this unique situation to create a children's paradise at the Enchanted Forest, one that appeals to all youngsters, as well as the young at heart.

All the houses and story-book buildings have been constructed of solid oak beams, heavy concrete and cinder blocks. Every effort has been made to preserve the rustic feeling in the design and materials used to build these structures. Wormy and antiqued effects are used throughout. Most of the attractions such as the Three Bear House are walk-in buildings, and many of the story-book figures will be animated and activated with voice and music. When a child asks "Papa Bear" to tell the story of his family, he will automatically oblige with a 90-second recital of his tale.

It was decided that the main building, forming the entrance to the park, would be the Enchanted Castle, which faces Route 40, running for a distance of 100 feet, including the walls. The castle towers are 40 feet high and the main section of the building is 35 feet wide. Of course, the castle has a real moat and drawbridge, creating the story-book approach to the Enchanted Forest. On top of the castle appears a 40-foot dragon, serenading the Princess Rapunzel with a tuneful lute. Also in the Enchanted Castle will be found Old King Cole, nominal ruler of the Forest—the jolly old soul who delights in good music, good food, and relaxation.

Here in the wooded glen by the side of a stream will be found more than a score of the characters and animals from the story books we all cherish…You must see them to appreciate the delightful expressions on the faces of all the characters.

And so visitors are transported into the land of legend—the Enchanted Forest includes characters, complete in their surroundings, as beautiful and full of fun and imaginative backgrounds as an experienced group of enthusiastic artists and builders can create.

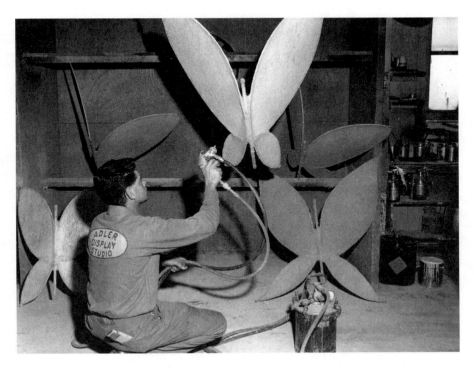

Howard Adler's Studio created such details for the park as these ethereal butterflies, meant to decorate the trees. *Courtesy of Linda Harrison Gardner.*

In addition to the major buildings and scenes, the Enchanted Forest will also have several bridges across the stream where you will find folks like Simple Simon, Jack be Nimble, and Little Bo Peep performing their stories. Throughout the park, little elves, butterflies, toadstools and other scenic touches will create the enchanted atmosphere.

A picnic grove adjoins the Gingerbread House, where refreshments will be on tap. Birthday parties will also be catered under the Sugar Plum Tree where the children will be served by waiters dressed as Mother Goose characters.

Live animals—goats, lambs, bunnies, Little Red Hen and other storybook animals will be pastured adjacent to the Big Red Barn. Ponys, as well as Mexican burro carts, will be busy transporting young guests.

The Harrisons aim to create a major tourist attraction for their home state, and their plans include a nationwide publicity campaign to invite families traveling into Maryland to spend an hour or an afternoon at the fabulous Enchanted Forest.

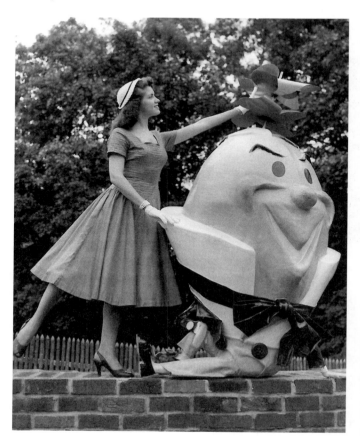

Anne Bell, Miss Enchanted Forest in the Miss Maryland pageant, attended the park's preview party. *Courtesy of Linda Harrison Gardner.*

A party was held the day before the Park officially opened. Gardner said, "Noted Baltimore photographer A. Aubrey Bodine was one of the guests, as was Miss Enchanted Forest in the Miss Maryland pageant." The whimsical invitation, decorated of course with the welcoming castle and jovial King Cole, said:

Hear Ye! Hear Ye!
[name]
Is hereby summoned to appear before
Old King Cole and his Court
At the wonderful
ENCHANTED FOREST
For a special Preview Party
Sunday, August 14, 1955
To be the guests of his Majesty
On a trip through Story book land

Children Note:
Be it resolved that all Ye Children
Accompany the above summoned to witness
The land of fantasy and merriment.

The reply card opened with:

Greetings, Your Majesty
From your Loyal Subjects

The tone was set.

The Park opened on August 15. The opening of the Enchanted Forest merited only a few paragraphs on an inside page of the *Baltimore News-Post* (no longer in operation). The article described the attractions available at the opening:

Entrance to the Forest is through a castle, complete with drawbridge, moat and gleaming white towers topped by orange roofs.

A huge green dragon surmounts one of the towers, while a fairy Princess awaits her prince on a balcony.

A step through the magic gates and youngsters find themselves in a virtual storybookland.

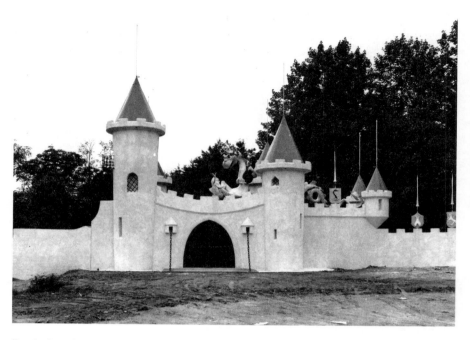

Just before the park opened, the dragon was in place on top of the castle, but Rapunzel had yet to arrive on her balcony, and the entrance area was still dirt. *Courtesy of Linda Harrison Gardner.*

First at hand is the Merry Miller, with a water wheel going round and round.

Next is a massive "look-inside" Easter Egg with live bunnies hopping about outside.

Along the winding path are the Tortoise and the Hare in their storied race, with the Hare napping as the Tortoise crosses the finish line.

Three neat little houses are ready and waiting for the Three Little Pigs—one straw, one twig and the third a nice, substantial brick dwelling for the solid citizen porker.

The Crooked Man has his Little House, defying gravity at every turn with its haphazard chimney and leaning roof.

Jack's Beanstalk shoots 35 feet into the air, with tremendous beans, five feet long, growing on the vine. Jack, himself, peeks from behind giant leaves which entwine the pole.

Sailing around on a large pond are the Three Men in a Tub—one pulling the other out of the water with his fishing rod, and the third perched atop the mast.

That cocky hare didn't stick with the race like the plodding tortoise did—so guess who won!
Courtesy of Linda Harrison Gardner.

A mouthwatering morsel is the Hansel and Gretel House, encrusted with make-believe lollypops, a 25-foot high ice cream cone, and with an ice-cream sandwich as the front porch roof.

The Three Little Bears have three little houses, a big one, a medium sized one and a tiny one for baby bear.

Visitors have only to ask Papa Bear, and he will tell them the story of Goldilocks.

The Old Woman in the Shoe and her legion of children happily are ensconced in a purple shoe with a yellow roof, and green shoestrings.

Children may enter the shoe at the heel, and go shooting out the toe on a sliding board. Also, they may climb the spiral staircase and look out of the windows on the second and third floor of the odd dwelling.

Various other nursery rhyme figures decorate the paths, and real live counterparts of Little Bo-Peep, Old Mother Hubbard and the like will stroll about the park.

By September, news of the Enchanted Forest made the front page of *Variety*, which said that the "Big Juve Lure" had twenty thousand visitors in its first week.

Cavey said, "After the Enchanted Forest was completed and getting ready to open, Mr. Harrison asked if Joe would manage the Park, and again Joe said yes. His job at the time was to get the employees started by going to the office and getting the cash boxes and giving them to the people working in the Castle and ticket booths, and in the snack bar, which in the beginning was located in the Gingerbread House. He would then get employees over to the parking lot to assist in parking cars in rows and putting on bumper stickers."

Just days before the Park opened, Hurricane Connie hit land in North Carolina and made its way up the coast to Maryland. It caused $86 million in damages and was closely followed by Hurricane Diane, which caused an additional $700 million in damages. The Park was able to open on time, but the landscaping was destroyed by the storms and had to be replaced.

Gardner said:

A lot of people told my grandfather and father that they were crazy for even trying to open something like this because it would never make it, especially not out in the middle of nowhere, which it basically was at the time. And the banks would not lend them money, so they had to use their own money from the sale of the Belgian Village because nobody had any faith that it would work. And when it was finally complete, and we opened, it was astonishing. People would park all the way up and down Route 40 and walk through the Park in a line—that's how many people came through. Just from everywhere. I was only eight when the Park opened, but I remember it was mind-boggling. We couldn't believe what was going on. My parents and grandparents had no idea how many would show up the first day. I remember sitting around the dinner table after the first day and someone said to my grandfather, "Do you think they think we're crazy now?"

It was so crowded that first year that we knew the Gingerbread House we were using as a snack bar just wasn't big enough. And we knew we didn't have enough parking. In the early years, 350,000 to 400,000 visitors would attend each season. The first additions after the initial year were a snack bar in the old dairy barn and enlarged parking. The original parking lot held 250 cars. Later, we made room for 700 cars.

Dave Garroway originated the Today Show *in the early 1950s. It came from New York. He had heard about these two "crazy" men who had opened a Park in the middle of nowhere and nobody thought it was going*

Children wait their turn for a peek inside this tiny house. The park was often very crowded.
Courtesy of Linda Harrison Gardner.

to make it, and he had heard how well it did. He brought his whole show out, down to the Enchanted Forest, in the first or second year. His chimp pal, J. Fred Muggs, was there too and was featured in later advertising for the Park. That made the Park even busier. When J. Fred Muggs arrived at the train station in Baltimore, we had a covered wagon at the station to meet him.

Chapter 4

Growing Up Enchanted

It is hard to imagine growing up living in a theme park. You think of the constant noise and the endless stream of strangers visiting. The Harrison children knew nothing else, having spent their earliest years living in a motel—one that was interestingly decorated, but a motel nonetheless. Many little girls pretend to be Cinderella, but hardly any of them have access to their own real castle and pumpkin coach. What an enchanted childhood the Harrison children had.

Gardner recalled:

> We lived right on the Park property. Mom said she raised her family in a goldfish bowl. The Enchanted Forest was our backyard. It was a wonderful place to grow up. We were allowed to wander through the Park as children. The whole family always worked there. The very first thing that I can remember being was Jill, and my brother Bruce was Jack. We were small, and we used to walk through the Park and we had a bucket, like Jack and Jill, and we would hand out little packets of magic beans and talk to all the people who would come to the Park. Later we were Hansel and Gretel. When I was little I couldn't wait to grow up so I could be Little Red Riding Hood, and I did finally get to be Little Red Riding Hood when I was twelve or thirteen. I really liked walking around and talking to the smaller kids who were so enjoyable, and they liked having their pictures taken with me and the other characters.
>
> It wasn't unusual for me to see other kids walking around the Park with my clothes on. They would fall into the water, and my mom would bring

them dripping into our house, sit them in front of the television and put their clothes in the dryer. They would wear my clothes while theirs were drying. This happened often enough that Evelyn Myers, who ran the snack bar, asked my father to put a washer and dryer in the back of the snack bar. Mom worked just as hard as Daddy did. She worried about everybody but herself.

My father never took a day off, but my mother used to take us kids to other amusement parks in the summer, just to see what they were like. My father used to wave goodbye, saying something like, "Hey you bunch of traitors, have a good time."

Susan White, who grew up in Catonsville near the Enchanted Forest, shared a memory. She said, "The Harrison family owned the Enchanted Forest. When I went to Trinity, [a high school in Ilchester, Maryland] Barbara Harrison was a senior and she hosted the Big Sister–Little Sister party. It was an overnight party at the Forest. I think we spent the night in Robin Hood's Barn."

The Park had a variety of animals. Gardner said, "The first night the peacocks were in residence, my mother, Geraldine, woke up in the middle of the night and woke my father saying someone must be trapped in the Park for the night because she could hear screams for help. He went to investigate, only to return to laughingly report that she would have to get used to the sound because it was the peacocks. The Park also featured ponies, Mexican burros, white-tailed deer and a variety of birds. Our family's dog, Checkers, wandered the Park all day. You would never be able to do that today." In the winter when the Park was closed, the Harrison children would ride the ponies through the snow and enjoy a very different atmosphere from when the Park was open.

Buddy Harrison, Howard Harrison III, is a very playful guy. Numerous stories exist of pranks he played, and jokes he told. Matt Veltre is a son of Barbara Harrison and Howard Jr.'s grandson. Veltre said:

I grew up at the Enchanted Forest. Oh my God, I loved that place. Just imagine how many lives my grandfather's vision touched. I had a good childhood and always felt safe. My family would often have get-togethers in the Park after it was closed to the public. We would take the Antique Cars out of their track and drive them all over the Park. And we liked to play in the Moon Bounce. We had to take our shoes off for that, and Uncle Buddy would take our shoes and spray them with water and stick them in the freezer.

Over the years I worked all of the rides, worked the concession stand and took care of the deer and every other animal we had. No matter who worked there, there was a feeling of family among all of us. We all got along. I remember playing softball with the other workers every Wednesday night in the summer at Centennial High School. The best time for me was the last two years the Park was open, when I got to live in my grandparents' house by myself. The commute to work was great. I loved walking through the Park alone after it was closed for the day. It was extremely peaceful. The biggest thing I liked was when the kids entered the Park for the first time. The look on their faces! They would stand there for about five seconds, just taking it all in, and then they would take off.

The Enchanted Forest was a family affair in every sense of the word. Generations of the Harrison and Selby families worked at the Park, and generations of many other families carried on the tradition of frequent visits. Cavey said:

Because my Uncle Joe was at the Enchanted Forest from the beginning, and our family was so close, we were interested in the Park right away. Even as small kids we were there every Easter Sunday and most weekends during the summer. I remember the Park being bigger when I went there as a child. I guess it's like that with any place you remember as a child. This was a really special place. There were all these odd-shaped buildings and odd rides—WOW. Even if you had the opportunity to do everything the Park had to offer, when you left you couldn't wait for the next time you would be back.

My wife, Linda, and I met in high school, at Glenelg High in Howard County. Linda started working at the park in 1967 when she was sixteen years old. She worked mostly in the Castle as a cashier in the gift shop. She worked there each season until high school graduation. After we got married and I got out of the army, Linda worked for a short period at the Park again, doing the same thing she did as a kid, only this time some of the days she worked in the gift shop at Robin Hood's Barn with Aunt Marlene. Lucky for us, her mother watched our daughter Carrie or the daycare would have been more than she was making. Carrie grew up to work in the Park too, in the same location as my wife: the gift shop in the Castle. This was in the early 1980s, not long before the Park closed.

Also, my grandfather worked there in the spring to get the Park cleaned up and ready to open for the season. So, including my uncles and me, four

generations of my family worked at the Park. During my time working at the Enchanted Forest I became good friends with Bruce Harrison, to the point that he was best man at my wedding.

After they grew up, three of the four Harrison children lived in houses on the property with their spouses. After he returned from the army, Norman Cavey, his wife and daughter also lived on the property, in a house next-door to Bruce Harrison. When the property was purchased by JHP Development in 1988, and the Park closed in 1989, the houses were razed. A Safeway grocery store now stands on the site. Howard Harrison Sr. died in 1967. Howard Jr. died in 1988. His wife, Geraldine, died in 2000.

Chapter 5
Visiting the Storybook Land

Charm, Innocence, Magic

The Park was "an amazing land of make believe" according to the brochures and had a down-home style not seen in the slicker amusement parks. In the beginning, the Park was smaller and charged an admission fee of one dollar for adults and fifty cents for children, with each ride an additional thirty-five cents. Later, a visitor had the option to pay one price (less than five dollars) to enter the Park and go on up to ten rides. It attracted 20,000 visitors the first week. In the first thirty days the Park was open in 1955, it welcomed 100,000 visitors. It was a success from the day it opened up.

Gardner said, "The Park was mainly for younger children. It was not for thrill seekers who like roller coasters or things like that. It was a place with a lot of imagination. There were telephone booths all through the Park, and they were old-time telephones, and you could pick them up and talk to Peter Rabbit or any of the other figures that were in the Park."

Cavey remembered:

> A lot of the buildings had tape machines in them that repeated a story over and over or was started by stepping on a mat that was in front of the door you were looking in or by pushing a doorbell. There were phone booths around the Park. In these phone booths were the old time phone that had an ear piece on a cord and you talked into an adjustable mouth piece. The phones were a wooden box-looking thing and had a crank on the side. I'm sure you have seen these old phones in old movies. There were phones for Peter Rabbit, Old King Cole, Humpty Dumpty, and Rapunzel. The

THE ENCHANTED FOREST

The Enchanted Forest is filled with exciting places to visit and familiar nursery rhyme characters to see. Watch the Three Pigs build their house of bricks and thwart the Big Bad Wolf and stop and pet the rabbits at the Easter Bunny's House. Listen to Willie the Whale laugh as you tickle him under the chin, and visit Goldilocks and The Three Bears in their beautiful little house.

You will love the many rides and the playground, as well as the delicious snacks served by The Merry Men in Robin Hood's Barn. Gift shops at both entrances are filled with special remembrances of a delightful day.
There are tame deer, goats, bunnies, ducks and a lamb that you can pet. A large free picnic area and plenty of free parking space are available.

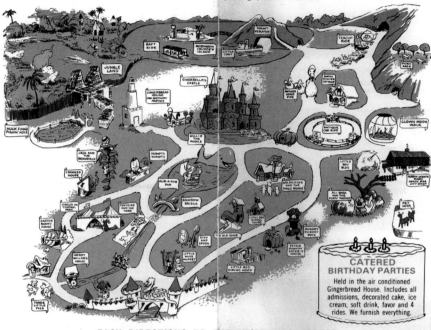

EASY DIRECTIONS TO THE ENCHANTED FOREST

From Washington, D. C. area . . . Take Route 29 and go west on U.S. 40 approximately 2 miles.

From Baltimore area . . . Take U.S. 40 west of Baltimore, just seven minutes from Exit 15 of the Baltimore Beltway. (On Route 70N westbound—use Route 29 Exit to Route 40; Eastbound—follow Route 40.)

From York, Pa. area . . . Take the Baltimore-Harrisburg Expressway south to the Baltimore Beltway—then west on Baltimore Beltway to Exit 15; 7 minutes west on U.S. Route 40.

From Wilmington, Del. area . . . Take the John F. Kennedy Memorial Highway to Baltimore Beltway—turn RIGHT onto Beltway—then continue to Exit 15; 7 minutes west on U.S. Route 40.

From Eastern Shore of Maryland . . . Take Route 50, cross Bay Bridge to Route 2, then take Baltimore Beltway west to Exit 15; then 7 miles west on U.S. Route 40.

From Virginia area . . . Take Route 350 to Capital Beltway (495) then to Route 29 and go west on U.S. 40 approximately 2 miles.

This map of the park includes the later features added to the park, like Mt. Vesuvius and Jungle Land. *Courtesy of Linda Harrison Gardner.*

problem with these phones was vandalism. People breaking into the Park at night or even people during the day when the Park was open would pull the receivers off and throw them in the pond or over the fence or somewhere where you couldn't find them. With this type of phone, replacement parts were hard to come by, so Uncle Joe and Uncle Bradley would have to remove a phone booth and use the remaining parts to keep the others going. After a while they were all gone.

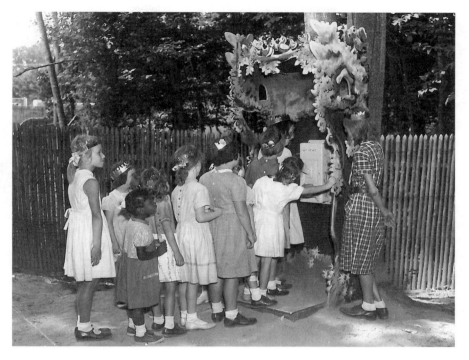

Telephone booths were scattered throughout the park, making it possible to call a variety of fairy tale characters. *Courtesy of Linda Harrison Gardner.*

In the early days, the only other Baltimore-area amusement park was Gwynn Oak in Woodlawn, which was open from 1893 to 1973. This was a more traditional park, with rides like the Whip, the Caterpillar, a merry-go-round and a roller coaster. They also offered pony rides but didn't have any storybook features like the Enchanted Forest.

In the late 1950s, the heyday of the Park, as many as ten thousand people would visit on a Sunday afternoon. Gardner said:

> *The parking lot could not handle that many cars so many people parked along Route 40, something unimaginable today. The state police would come out for crowd control. The Park usually opened on weekends after Easter, then every day from Memorial Day to September. Up to 250,000 people came each season in the early days. In these casual days, it's hard to imagine that visitors on Sunday actually got dressed up. Ladies wore dresses, hats and high heels. Men wore suits and ties, and the kids wore their "Sunday best." At the time, so-called Blue Laws were in effect in*

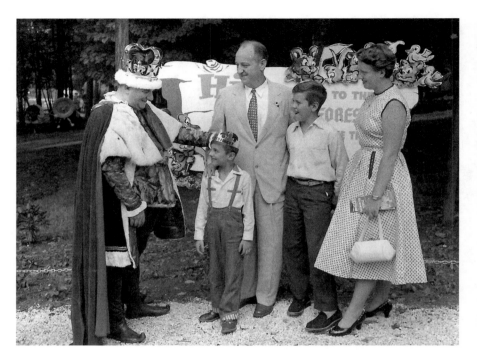

Families would get very dressed up to visit the park. Men would wear ties and women would often wear hats, gloves and high heels. *Courtesy of Linda Harrison Gardner.*

> *Maryland, restricting business on Sunday. My father argued that Blue Laws were in place to keep families together on Sunday, and that was the goal of the Enchanted Forest. We were allowed to remain open.*

There is a Facebook page dedicated to keeping the memory of the Enchanted Forest alive. All of the people who post on this page visited the Park as kids. Some of the people have continued to do what they can to preserve the features that have been transported to Clark's Elioak Farm. Among them are Monica McNew-Metzler, Susan Eldridge, Leslie Watts Azzarelli and Meredith Peruzzi.

Many visitors to the Enchanted Forest over the years have fond memories of time spent at the Park. Debbie Baker Redmon said, "In 1962, Mom, Dad, my brother Walter and I put on our Sunday best to visit Enchanted Forest. My mom was actually wearing a suit and I am sure that Dad had a tie on…for an amusement park! I think I remember that there were little cars to drive and being very disappointed that my parents thought we were too young for that. The early 1960s—what a wonderful time to be a kid!

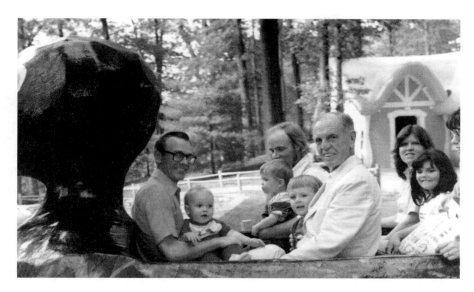

The Bell family. *Courtesy of Ellen Bell.*

Today, this amusement park would be so 'lame' for kids, with the lack of technology...for us that day was magic!"

Ellen Bell recalled, "This photo was taken on May 30, 1981, on one of the Enchanted Forest rides. It is a special photo because it was our last visit with Grandfather Bell. He is in the light jacket—it was probably a blue and white striped one. He always wore a shirt, tie and jacket whenever he went out—no matter the weather! Our son Mark is sitting in Grandfather's lap. We were celebrating Mark's fourth birthday. Sitting in my husband Fontaine's lap is our son Scott, about to turn one in a few days."

Janet Kusterer said, "I grew up in Catonsville, near the Enchanted Forest. I remember going there as a child, and it was a treat to bring my older son Dave there when he was in kindergarten. We were living across town at the time and were due to move to Ellicott City in a few weeks. We were happy to be moving closer to the Park rather than farther away. I went to high school with Linda Harrison. When we returned to school after summer vacation, each of us with tales of summer employment at grocery stores and shopping malls, it was fun to listen to Linda report that she spent the summer as Little Bo Peep."

Mark Cline remembered visiting the Park as a child. He said:

I was born in Waynesboro, Virginia, in 1961, but had several relatives who lived in the Baltimore area. My mom and dad would drive up in

the old station wagon, hauling me and my three brothers up to see all the kinfolk. We stayed with my grandma, my mom's mom. Back in that day, vacations were two weeks. A good week of that was spent at Grandma's. To fill the time, our parents took us to the local attractions. I remember going to the Baltimore Zoo, Gwynn Oak amusement park and especially the Enchanted Forest.

The first thing to look for was Ole King Cole perched way up on his pole. Excitement swelled as one of us would spot him from way off and loudly announce we were getting close. I remember I could hardly wait for the car to turn into the parking lot and stop so we could all head toward the entrance and enter into a day filled with fun and imagination. Puff was always there on top of the castle entrance to welcome all his "friends." I distinctly remember how the anticipation grew as we walked toward the gate and looked up at Puff. Once inside, it was every kid for himself. To me it was better than being in a candy store. [Note: Cline calls him Puff, but the dragon didn't have a name.]

The Enchanted Forest wasn't just a local attraction. Once word spread through venues as notable as the *Today Show*, people came great distances to enjoy the Park. Lisa Peklo said:

Soft thrills. Low tech. Enchanted Forest was quite simply enchanting. My introduction to the original Enchanted Forest was in the early 1960s. My mother was a timid driver, so it was a great excitement when my brother and I learned that she would drive us all the way from Montgomery County. We traveled out the then two lane Route 29 to Route 40 west to what was then billed as "Maryland's major tourist attraction" in an Enchanted Forest flier from the era. We loved the place. I recall that my brother took a shining to a young lady who portrayed Little Bo Peep. Her name was Patsy Selby. This was more than fifty years ago, but I still remember the incident. I thought she was surely a celebrity and loved the attention she showed my older brother. Coincidentally, I learned that in 2009 when the "new" Enchanted Forest at Clark's Elioak Farm was holding a reunion of Enchanted Forest employees, the very same Patsy Selby was on the committee!

We were amazed when a tourist approached our mother and said he wondered if she was from Shamokin, Pennsylvania. In fact, our mother was from Shamokin originally, and this fellow picked up on her accent. All this took place in Ali Baba's Cave, and I can recall the humid, musty atmosphere as if it were yesterday.

We loved Enchanted Forest, and little did we realize that we were enjoying nostalgia without even knowing it. The very slow-paced, meandering walkways, simple but thrilling "rides" like the Jungle Ride to Robinson Crusoe's Island with the hidden jungle animals, the huge slide at Mount Vesuvius, Cinderella's Castle and the clamored-for Robin Hood's snack bar. All of this was absolutely delightful to youngsters who were living the fairy tales through the charming tableaux at Enchanted Forest.

When we took our son to Enchanted Forest in 1982 for a birthday party, a special and unexpected treat was the arrival of a Baltimore children's television legend "Captain Chesapeake." Captain Chesapeake has entered the realm of nostalgia just as Enchanted Forest has. I only went the one time in my own childhood and was thrilled to be able to introduce my own kids to the same. We took our son many times during the early 1980s. Our daughter was a visitor just a few times before the Park eventually closed.

I recall the day we were at the Forest Diner with our family sometime near the end of Enchanted Forest's long run. The diner, directly across from Enchanted Forest, had a perfect view of the "fence" of dancing Gingerbread Men. These iconic figures shouted out fun. Longtime waitress at the Forest Diner, Dorothy Asbury, had tears in her eyes when she learned of the announced closing of Enchanted Forest. Dorothy said, "I'd love to have one of those Gingerbread Men." I often have hoped that she got one.

I remember when an episode of the television series Homicide *was filmed in part at Enchanted Forest. What a hoot that was. This was the era of the worst decline of the closed Park and so the setting took on an eerie feel.*

I always hoped I would be able to bring my grandchildren to the Enchanted Forest so the efforts of those who saved the varied tableaux and re-purposed them at Martha Clark's Elioak Farm are forever in my debt. Though it's not quite the same, it was a joy to bring our grandchildren out to the "rides" at Enchanted Forest in its new location. What a blessing to have had three generations of our family enjoy this once enchanting place.

Sue Eldridge has been very instrumental in keeping the Park in the hearts and minds of the people who loved it. She frequently posts on Facebook, and she recalled:

I remember going into Robin Hood's Barn to get some drinks for us with my dad. I was only five years old, so being little meant always having to look up to talk to grown-ups. We waited in a line, and I remember looking up

to talk to my dad and then I gasped. I pointed them out to my dad. "Dad! There's men fighting in the lights!" (I think I may have said Peter Pan. I wouldn't be surprised that IF Peter Pan ever grew up, he became Robin Hood. Same outfit.) He looked and then laughed. He explained that it was Robin Hood and how he was a good guy. He was fighting a bad guy, and the light was called a chandelier. What an amazing place it was when it came to creativity. One thing I love is that it seems that the people who had a chance in designing the Enchanted Forest were aware of how children spend a good part of their day having to look up at people. To make the child's experience memorable, these were just a few things that were designed in the Enchanted Forest, so that a child could see easily and enjoy them: the men in the chandelier in Robin Hood's barn, Alice falling down the hole in the tunnel, I think you also looked through a keyhole to see the garden in the Alice tunnel. There were also the keyholes at various heights in the Grandmother's cottage for Little Red Riding Hood, the small antique cars, the boy and girl gingerbread men. And the structures! Especially the rock-a-bye-tree. This was where the three fairies from Sleeping Beauty brought her to live, so the evil Queen could not find her. Rock-a-bye was the structure that to a child was like having their very own home: there was a small concrete table and chairs and even a fireplace inside. The original Robin Hood was found years ago and is now displayed at Clark's Elioak Farm fighting another man—minus the chandelier.

It's interesting that such a sweet, mild-mannered Park would hold a few attractions that might instill a bit of fear in a small child. As Meredith Peruzzi said:

I was eight years old when the Park closed in 1989, so I remember it through the eyes of a fairly young child. My strongest memories are of being scared! I was scared that Little Toot wouldn't make it back to shore, but even more terrifying was the Ali Baba ride. Looking back on it, I think it must have been that the ride was enclosed…it made it that much scarier, to be in such an immersive environment, as a small child. But I also have fond memories of the slide in Old Mother Hubbard's Shoe, Cinderella's Castle, and waiting in line to ride the mice…I'm not sure why I remember the line, I guess the mice were just that popular that the line made an impression!

Charlene Clark, of Charlene Clark Studio, is an artist who likes to paint images of places and things that no longer exist. Clark recollected:

I grew up in Catonsville, and we belonged to the Turf Valley Country Club. We would ride by the Enchanted Forest every day in summer on our way to the pool at Turf Valley. It was such a treat to ride by the Park and see the figures by the road. I recently painted a series of scenes from the Enchanted Forest. I painted Old King Cole from the front and the back as we would see him that way, coming and going.

I was born in 1951, so I remember the Park from the beginning. When I was seven years old, I convinced my mother to let me have my birthday party at the Park. It was the best birthday I ever had. We had cake, and I got lots of presents. One feature of the Gingerbread House where the party was that I remember was the oven—you would get in the oven, and the lights would go on and you would slide out to the outside. My party was in the evening, and I remember we could run all over the Park after the party. I liked being with my friends, but I also liked wandering around by myself. The Enchanted Forest let you enter into fairy tale books. I liked being in the tunnel with Snow White's dwarfs by myself. The Park allowed me to be a little scared.

I never got to eat in Robin Hood's Barn. Back then eating out was a real treat. My mother would usually pack us a picnic instead. The Merry Miller was a little creepy, but I didn't mind him. He was in there by himself and had a strange voice. I did like the phone booths—everybody loved to talk to Rapunzel.

One Sunday in the late 1980s, I woke up and got the paper and read that it was closing time for the Enchanted Forest. I bought some film and spent the whole day out there, taking pictures. I remember thinking how well they were taking care of the gardens even up until the end.

I was painting papier-mâché fish in the window of a popular arts and crafts store in Owings Mills Mall in 1988 when Howard Adler walked in and started talking to me. He wanted to see how I worked with the papier-mâché, but I was only painting at the store then. I was truly star-struck to meet him, and told him that I was inspired in my work by his work at the Enchanted Forest. He couldn't have been nicer—he was a dear person and it was a delightful experience to meet him.

During the 1950s and early 1960s, segregation was still widespread, and many Howard County businesses turned away African Americans or required separate facilities for whites and blacks. The Enchanted Forest welcomed everyone from the first day it opened up. According to Gardner:

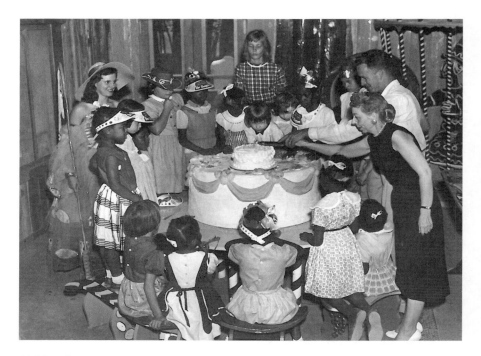

Children from the Washington Children's Village helped celebrate the park's first anniversary. *Courtesy of Linda Harrison Gardner.*

My parents loved all children. On the first anniversary of the Park he [her father, Howard Jr.] threw a party and cut a cake to celebrate. The children from Washington's Junior Village were guests of the Enchanted Forest at that party on Monday, August 27, 1956. The Ellicott City bakery, Leidig's, provided a gingerbread cake as well as big gingerbread man cookies.

We never had any trouble at the Park because of being integrated. When we first opened, we had integrated bathrooms, but black people came to my father and asked him to put in a separate bathroom for them, just to avoid any problems, so we did that for a few years.

The fact that the Enchanted Forest was integrated from the day that it was opened is significant in the history of race relations in rural Howard County. The Harrisons took a chance that some people would stay away from the Park because it was integrated, but they knew that their policy was the right thing to do and never wavered in their commitment to serving all families in the region.

The history of the civil rights movement in Maryland shows that other parks fought efforts to integrate. In fact, Gwynn Oak Park received national attention for its segregated stance and was finally forced by public pressure to integrate. It is important to recognize the contribution of the Harrison family to the progress of civil rights in Maryland by opening as an integrated Park in 1955.

The Park experienced a decline in the 1970s as people were more attracted to the larger parks like Kings Dominion. On a typical summer Sunday in the 1980s, as many as 4,000 people would visit the Park on a weekend. In 1984, about 100,000 people visited in the course of the season.

Chapter 6
A Tour Through the Enchanted Forest

Old King Cole beckoned people driving by on Route 40 to enter the Park. He remains there to this day, welcoming people into the shopping center that took the place of the Park. A charming fence made out of pink and brown gingerbread men once lined the front of the Park. Other gingerbread men were scattered inside.

The original entrance was the Enchanted Castle, which faced Route 40, and was one hundred feet long. The towers are forty feet high, and the main section of the building is thirty-five feet wide. There was a moat and a drawbridge.

Cavey said, "Before the Park had its special discount ticket system, which included admission and a number of rides to ride all for one price—one price for adults one price for children—each ride had its own ticket. Right on the ticket was the name of the ride. If I remember correctly, all the rides were twenty-five cents, except Little Toot and Mother Goose, which were fifteen cents each. After a while all the rides became twenty-five cents each and eventually went to fifty cents each. The Lighthouse at the lake sold tickets for the rides down there, and the ticket booth on the hill at the playground sold tickets for the rides there. Since each ride had its own ticket, we would know how many people rode that ride that day."

A tour of the Park would begin at one of two entrances. Gardner remembered:

One was the Castle Entrance. It's one of the things that are still there. It's the entrance to the Enchanted Forest Shopping Center now. If you went in through the Main Entrance Castle, you could see Sleeping Beauty underneath, with the

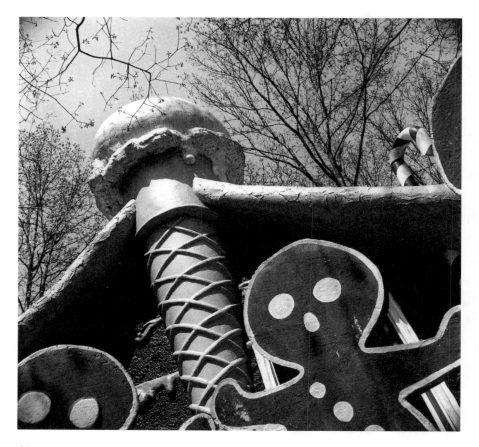

Gingerbread men formed a fence along the front of the park, and guarded the Gingerbread House as well. *Courtesy of Linda Harrison Gardner.*

Prince leaning over her, waiting to kiss her awake. A big green dragon played a mandolin on the roof, serenading Princess Rapunzel. All of the visitors got crowns. When you passed by Sleeping Beauty, you could take the paths either to the left or the right. Originally there were two dozen attractions in the Park, including Jack's forty-foot-tall beanstalk and the Three Little Pigs.

You would walk down a ramp and first see a welcome sign decorated with woodland creatures that said, "Hi, Welcome to the Enchanted Forest, where fairytales come true." At the Park, you walked around. When you looked into one of the houses, like Little Red Riding Hood's Grandmother's House, inside was the wolf, in Grandmother's bed, dressed up in Grandmother's clothing. You would push the doorbell and hear the wolf tell a story.

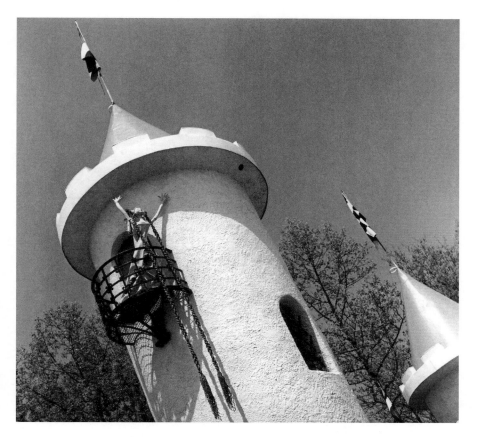

From her balcony, Rapunzel welcomed visitors to the park, her long braids flowing. At the door to the castle, a phone relayed a message from her to visitors. *Courtesy of Linda Harrison Gardner.*

Later a second entrance was added in Robin Hood's Barn to accommodate visitors who parked in the back parking lot.

The man behind many of the voices telling the stories was Walter Allen Teas Jr., a former AM radio morning host who was also a freelance announcer and a commercial narration artist. When the Enchanted Forest opened, he was hired to do the voices of Willie the Whale and other characters. During his career, he also narrated tapes used by the National Park Service at Independence Hall in Philadelphia and at the Gettysburg Battlefield.

Gardner said:

> *The houses of the Three Little Pigs were among the first things you saw. The first house was straw—there was not a lot of house, as it looked like*

Little Red Riding Hood at Grandma's House. *Courtesy of Linda Harrison Gardner.*

it had been blown down by the wolf. The second house, made out of sticks, was more substantial but was still blown down by the wolf. Last was the brick house, built really well, with a pig in the chimney. When you rang the doorbell of the brick house, the pig would tell you the story of the wolf. Daddy spent a lot of attention on the details inside the houses. Kids didn't notice so much, but their parents did. In the pig's brick house, there was a wolfskin rug and family portraits of the pigs.

Across from the pigs was the Merry Miller's House. It was a cute little house, with mice all around it singing songs—the Happy Mouse Band. Some kids found it scary because the Miller's voice sounded harsh, but I liked it. There was a pond next to the Miller's house. When they started to dig it, they ran into springs.

Next you passed the chocolate Easter Egg that Peter Rabbit lived in. Kids loved it. It was surrounded by a little fence that held baby rabbits. The Little Chapel was next. It was a simple place—two arched trees bent over benches where you could sit and listen to the Our Father being sung and to enjoy the peace of the river running behind it.

Even after all these years, former visitors can close their eyes and retrace their steps along the wandering paths, past tiny houses, butterflies and bunnies. Goeller remembered:

Two-year-old Melanie St. Ours meets one of the Three Little Pigs on a visit in September 1985. *Courtesy of Joan St. Ours.*

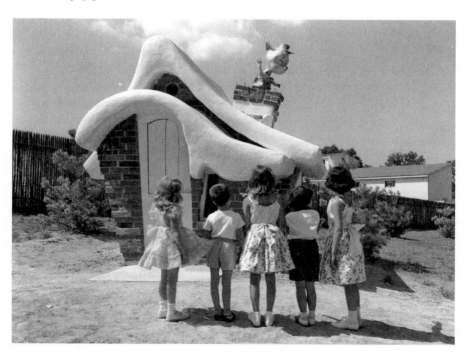

The wolf huffed and puffed but couldn't blow down the third pig's sturdy brick house. *Courtesy of Linda Harrison Gardner.*

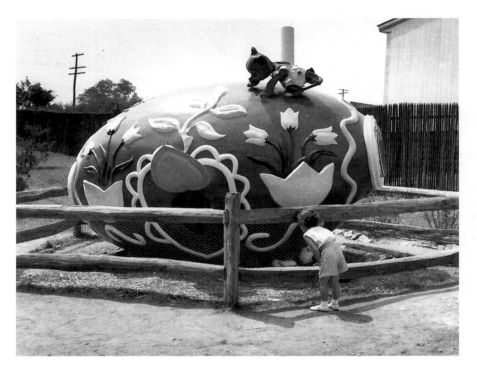

The chocolate Easter Egg was home to live bunnies. *Courtesy of Linda Harrison Gardner.*

My mother was a teller in the Equitable Trust Bank in Westview Shopping Center, where Howard Harrison Jr. banked. One Easter my parents gave me two ducklings that I named Pick and Peck. They lived in our backyard until it got cold, then my mother arranged with Mr. Harrison that they could go live at the Enchanted Forest. They lived along the banks of the pond where Mount Vesuvius was. Another Easter I got a bunny named Peter. He also went to live in the Easter Egg at the Park. My mother would take me over there to visit, and I swore I could tell which ducks were Pick and Peck and which bunny was Peter. It was so neat to have pets that lived in the Enchanted Forest.

The Park has been closed for so many years, but people still hold on to their precious souvenirs of their magical visits. Wallets, pens and postcards bring back so many fine memories. Karen Griffith grew up in Howard County. She said:

I went to the Enchanted Forest several times and loved the Old Lady who lived in the Shoe. And Robin Hood's Barn with its gift shop and restaurant was a

favorite too. There were Robin Hood figures attached to the wagonwheel light fixtures above. I got a box of skinny pencils with arrows on top like Robin Hood's and a souvenir Enchanted Forest fat pencil too. I kept them for a long time. I loved the gift shop. One year, my sister Gail entered a contest, which was sponsored by Westview Shopping Center. It was to color an Easter egg picture, and lo and behold, she won a white bunny rabbit! Daddy built a hutch, and he lived with us for quite a while. However, somebody decided that the rabbit should go to the Enchanted Forest, which was not far from our house. His new home was at the giant Easter Egg House and enclosure so we could visit anytime.

Gardner said:

After visiting the Chapel, you could see the Crooked House with the Crooked Man sitting on his Crooked Stile, accompanied by a Crooked Cat and Crooked Mouse. Everyone loved the colors of that house. People also liked to have their picture taken pretending to hold up the house. Next were Jack and the Beanstalk. The Beanstalk was made out of a telephone pole. Then you came upon Humpty Dumpty, sitting on his brick wall. Kids loved to pat him and have their picture taken with him.

Willie the Big Blue Whale was across from Humpty Dumpty. Willie the Whale was a grinning twelve-foot-long blue whale. My favorite attraction when I was young, and when it first opened up, was Willie the Whale because you used to be able to tickle Willie under the chin, and he would laugh and you could climb in his mouth and you could look down his throat and you could see fisherman Jonah on a raft, inside Willie. When I got older, Cinderella's Castle was my favorite.

After Willie you saw Rubba Dub Dub, Three Men in a Tub. Then you came to the Rainbow Bridge, which was a popular sliding board that ended in a pot of gold. There was also a nursery rhyme bridge. Next to that was the Old Woman's Shoe, which was also a sliding board. Kids really liked the slides and liked to do them over and over. So there were plenty of benches and mushrooms made out of cement for parents to sit on and watch while the kids slid. On the top of the Shoe is where my brother Bruce and I would hide when it was time to go to the dentist. You could hear over the PA, "Bruce! Linda! Come to the house." And we knew it was a dentist appointment, but we didn't want to go to the dentist.

Sliding boards were among the favorite activities in the Park. The one in the Shoe was partly enclosed, and kids would slide down over and over again,

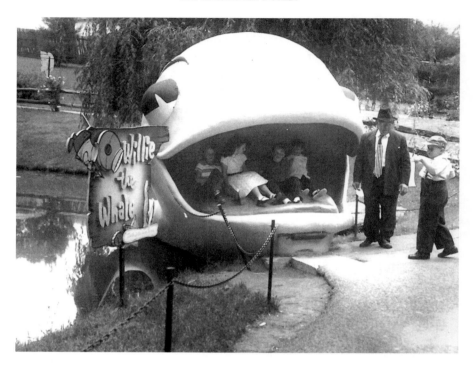

Willie the Whale was a great crowd pleaser. He would laugh when you tickled him. *Courtesy of Linda Harrison Gardner.*

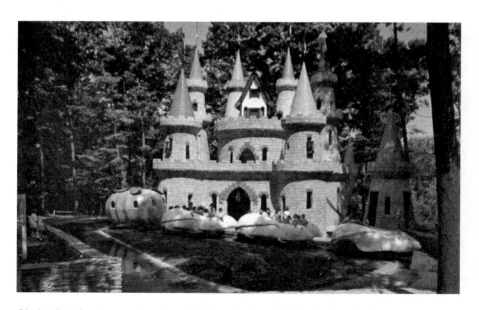

Cinderella's Castle was a favorite of visitors. *Courtesy of Linda Harrison Gardner.*

sometimes trying to hide from their parents who were patiently waiting just outside. Leslie Watts Azzarelli shared:

> *I remember Willie the Whale very well. I loved it but was scared to death of it too when I was very small. But I always went straight to it. I remember my dad asking what we wanted to do on the weekend, and I would always answer, "Go to the Enchanted Forest!" I think my dad had as much fun there or more than we did. I remember playing on the Rainbow Slide, and my father would ask us for the fifteenth time if we were ready to go on the boat ride and sliding board. When we left, he would always let us pick something out from the gift shop (many of the items I still have packed away). Those memories will forever be engraved in my mind. It was a wonderful place for a child!*

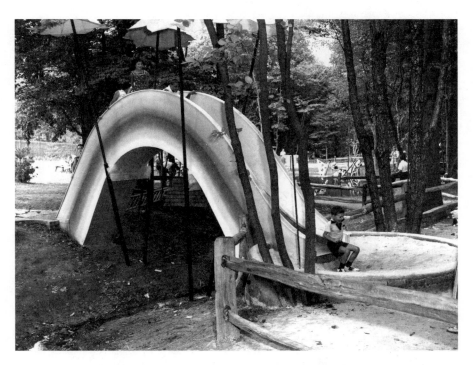

The Rainbow Bridge was a brightly colored sliding board. *Courtesy of Linda Harrison Gardner.*

Next page, top: This bridge offered nursery rhymes along its sides. *Courtesy of Linda Harrison Gardner.*

Next page, bottom: The Old Woman's Shoe featured a sliding board inside, as well as shoelaces made from fire hoses. *Courtesy of Linda Harrison Gardner.*

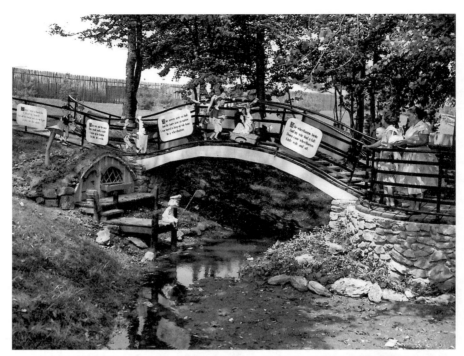

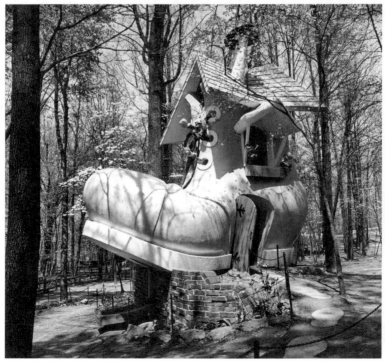

Hickory, Dickory, Dock was one of many nursery rhyme attractions scattered throughout the park. *Courtesy of Linda Harrison Gardner.*

Linda Harrison Gardner has been in love with the Park her entire life. She is one of the staunchest supporters of Martha Clark's project to save so many of the attractions at her Clark's Elioak Farm. Gardner said:

> *Next along the path was Hickory Dickory Dock, a big clock with a mouse hanging off of it. Then there were Little Miss Muffet, with a big spider next to her, and the Dish and Spoon. Each of these was accompanied by large signs with the relevant nursery rhymes printed on them.*
>
> *Little Red Riding Hood's Grandmother's House was really pretty. There was a beautiful comforter on the bed and lace curtains on the window. The wolf, who was in the bed, told the story. Like many of the buildings in the Park, this house had Dutch doors. The top half opened all the way so you could see inside. For the smaller kids, there was a keyhole opening in the lower door so they could see inside too. A lot of things were done for the children. I can remember taking my daughter Lisa to see the big tree. Rock-a-Bye Baby hung from the tree, and you could go inside the trunk of the tree*

Keyhole windows in doors offered views for visitors of every height. *Courtesy of Linda Harrison Gardner.*

and there were little chairs and a table. Now, a lot of adults couldn't get in there, because I can remember my daughter going in there and not wanting to come out. The buildings were small, and although adults could go in most of them, they were definitely designed more for children than adults.

Cavey said, "The Rock-A-Bye Baby Tree was really called the Good Fairies' Tree House, but when most people saw it, the first thing that came to their minds was Rock-A-Bye Baby, because of the baby Sleeping Beauty rocking on one of the tree limbs."

People fondly had their own special names, or nicknames, for some of the attractions. Gardner remembered:

Next to that was Peter Peter Punkin Eater's Pumpkin. Behind the Pumpkin and the Grandmother's House was an enclosed area that featured white-tailed deer. One time a neighboring farmer ran over a deer in his field, and the deer lost a leg. The farmer didn't think the deer would survive in the

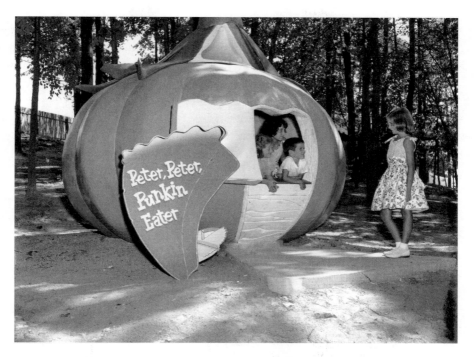

Peter Peter Punkin' Eater's pumpkin holds some cheerful children—Bruce and Barbara Harrison and their cousin Diane Bolger, as well as Peter's wife. Linda Harrison looks on from outside. *Courtesy of Linda Harrison Gardner.*

wild and asked my father to take it. My father didn't know if our deer would accept it either but took it in anyway. It lasted for a little while.

The Little Red School House was next. It had big, old-time desks and a big blackboard and an old schoolteacher by the entrance. My brother Bruce and I would play school in there when the Park wasn't open. There were little elves and bears in the forest next to the schoolhouse. Then there were the Three Bears' houses, attached in a row. They were so neat inside. When you rang the doorbell, Papa Bear would tell the story in a brief ninety seconds. All three of the bears were inside Papa Bear's house. It had family portraits and a stuffed hunter "trophy" over the fireplace. In the beginning you could see Goldilocks peeking out of Momma's window. Later on it was Baby Bear. Momma Bear's house had three beds in it but not much else. You could see the attention to detail in the chimneys. Papa's was a corncob pipe, Momma's was a purse and Baby's was a baby bottle. There were lots of mushrooms around there to sit on, and giant butterflies in the trees made out of fiberglass.

Adler's attention to detail was evident even in the plaster on the walls—which looked like it had been applied by a heavy bear claw. Gardner shared:

> *The original Park ended right at Hansel and Gretel's Gingerbread House that had gumdrops on the roof and an ice cream cone chimney. Evelyn Myers ran the snack bar in the Gingerbread House and later in Robin Hood's Barn. Her sister, Eleanor Taylor, worked in the entrance Castle for many, many years. Evelyn served hot dogs, hamburgers, French fries and ice cream. The Gingerbread House later became the site of birthday parties, but there was no room for those the first year. The first major change made in the Park was clearing land of its thick forest for more parking. The second was redoing the dairy barn and turning it into a snack bar. After the snack bar was moved we were able to host birthday parties in the Gingerbread House. There were parties every hour. A lollipop by the front door would list the name and age of the birthday child.*

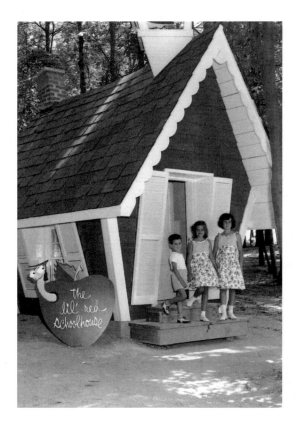

The Little Red School House, circa 1957, with Bruce, Linda and Barbara Harrison. The children would play school there when the park was closed. *Courtesy of Linda Harrison Gardner.*

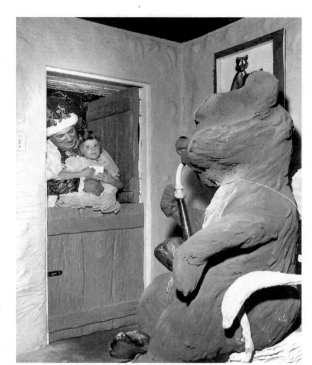

Right: Papa Bear was one of the figures that spoke to children when they rang the doorbell. *Courtesy of Linda Harrison Gardner.*

Below: The Three Bears House featured chimneys for each—a corncob pipe, a purse and a baby bottle. *Courtesy of Linda Harrison Gardner.*

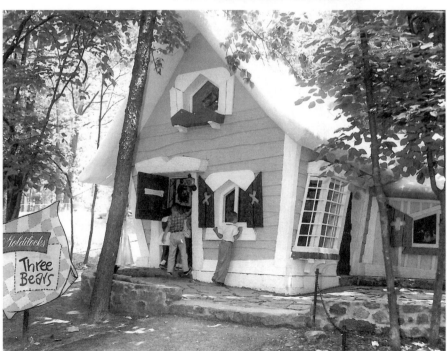

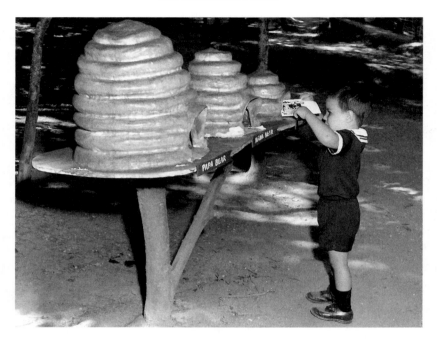

Even the beehives were sized to fit Momma Bear, Papa Bear and Baby Bear. *Courtesy of Linda Gardner.*

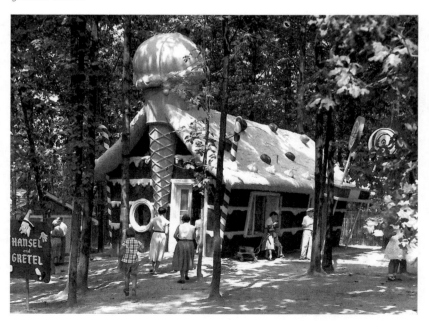

The Gingerbread House started out as a snack bar but was soon turned into a venue for birthday parties. *Courtesy of Linda Harrison Gardner.*

Evelyn Myers worked in the snack bar in Robin Hood's Barn for many years. *Courtesy of Linda Harrison Gardner.*

The Candy Cane Jail in the Gingerbread House didn't seem to scare this little girl. *Courtesy of Linda Harrison Gardner.*

The inside of the Gingerbread House was very whimsical. There was a big birthday cake in the middle of the table, and streamers coming down from the ceiling—all made out of fiberglass although they looked like paper. There were little chairs around the table, each different—like slices of pie and watermelon.

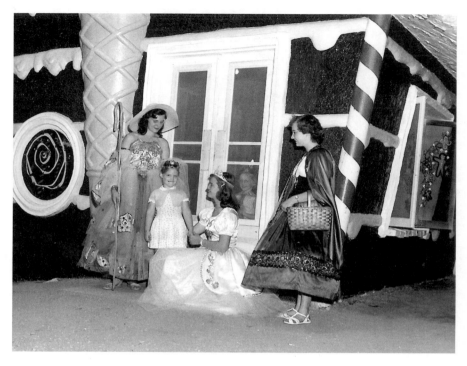

Little Bo Peep, Cinderella and Little Red Riding Hood enhanced many birthday parties at the Gingerbread House. *Courtesy of Linda Harrison Gardner.*

We would provide cake, ice cream, soda and two free rides to the party attendees, and a pinwheel full of candy. They would have an hour for the party in the Gingerbread House and after eating their cake and opening presents Little Red Riding Hood and Little Bo Peep would play games with them.

As children, many are happy to have their birthdays during the school year so they can share the day with their friends. Summer celebrations turn out to have advantages too. As Goeller said, "I have a summer birthday, and I loved having my birthday parties in the Gingerbread House. All the girls in my neighborhood would come, and they would serve a gorgeous cake. Cinderella would come and cut and serve the cake. Later, I was really happy to be able to take my son Joe to the Park too."

Some Park jobs took place off-site. Norm Cavey was for a while tasked with retrieving the birthday cakes from the iconic local bakery, Leidig's. This was a very popular bakery on Main Street in the historic district of Ellicott City. It had great bakery items and no parking. Cavey explained:

Each birthday child received a card, and all partygoers received tickets for two free rides. *Courtesy of Linda Harrison Gardner.*

Part of my job was to drive the station wagon to historic Ellicott City and pick up the birthday cakes from Leidig's Bakery. Depending on the size of the party, these cakes would range from a round layer cake to a quarter sheet cake to a half sheet. Also, the Enchanted Forest sold gingerbread men cookies and gingerbread cake with a white icing. The gingerbread cake was in a sheet cake form and in a stainless steel tray, I guess about two feet wide by three feet long. On Saturdays and Sundays, there were times when the birthday parties were booked every hour from the time the Park opened until it closed. So I would fill the car with cakes and gingerbread men cookies and cakes.

Old Ellicott City not being the easiest place to find a parking spot, I would usually double-park in front of Leidig's Bakery on Main Street, run in and get the cakes as fast as I could, and go. One Sunday morning I was running late and arriving at Leidig's, and again there was no parking, so I double-parked. It was probably a little after 10:00 a.m., and there was

a party at the Gingerbread House with no birthday cake because I was late. I ran in and got a couple of cakes in my hands at a time, running back and forth. Finally I got to the last thing I needed to pick up. It was a gingerbread cake—you know the one with that great white icing everyone loved. Well, I grabbed up this sheet cake and to get through the crowd of people in the bakery (which Leidig's always had after church), I held the sheet over my head with one hand like a waiter in a restaurant, and when I turned to go out (I was then standing in the middle of the crowd), the tray slipped out of my hand because it had just come out of the freezer and had frost on the bottom. Well, this gingerbread cake with icing landed upside down, and icing sprayed out in all directions. Everyone in that bakery had icing from their knees down, and on their church clothes. All I could do was stand there with my mouth open, looking at all these people in their Sunday best, covered with icing, and telling them how sorry I was and to send the cleaning bill to the Park. But when the people realized that I was from the Enchanted Forest, they said don't worry about it and to go on. I went back

The covered wagon and pony rides were the only rides available when the park opened.
Courtesy of Linda Harrison Gardner.

and told Uncle Joe what had happened. I asked him later, and he said no one had called. That was just amazing to me.

There were only two rides when the Park first opened—pony rides and a covered wagon ride, drawn by two mules. The Mother Goose Ride and the Cinderella Pumpkin Coach Ride came later. The original Park's back boundary was marked by Humpty Dumpty's wall and the picnic grove. Everything situated in the Park beyond the Gingerbread House and the picnic area was added after the first year. The Harrisons tried to add something new every year.

Cavey said, "Back in the summer of 1963, I was fifteen years old and because of being under sixteen and not able to operate a ride with a motor, I was either on the parking lot directing cars to their parking spot and putting on bumper stickers or walking the ponies. Walking the ponies was a job that was so redundant—you just walked around in a circle with a pony stepping on your feet all the time. When the child was older you could walk in front of the pony so that was okay, but when the child was small you had to walk beside the pony and help hold them on. That's when the pony would step on your foot."

The first mechanical ride introduced at the Park was Mother Goose, which was fifteen feet high. The ride offered a trip around the Park on either Mother Goose or one of her goslings, ending with the Ugly Duckling. Cavey said, "Mother Goose had a war surplus jeep under her, with the body removed and the steering wheel shaft, clutch pedal, brake and gas pedal lengthened."

Little Toot offered a cruise around the lake and through the tunnel in Mount Vesuvius. Gardner said:

I remember once when I was a student at the Cathedral Elementary School in Baltimore, my father asked me to get a copy of the Little Toot book out of the library. Then they started to dig the lake and found springs popping up, like they did in other areas of the Park. They needed bulldozers to pull out equipment that got stuck. The Little Toot boat was built in Baltimore. When it was done, my father called the school and told them I didn't need to go home on the bus that day and that he would pick us up. We went out in front of the school to wait for him, and he pulled up in the Enchanted Forest station wagon, pulling Little Toot on the back. I was mortified. It's funny—the first time I saw Little Toot I was so embarrassed, but when I saw it being delivered to Clark's Elioak Farm I was so happy.

Little Toot took visitors around the lake, through Mount Vesuvius and past Robinson Crusoe's Island. *Courtesy of Linda Harrison Gardner.*

Mount Vesuvius was built the winter after Little Toot. This was a major project that took all winter and had to be done in addition to the usual maintenance and painting. Mount Vesuvius was a neat project to watch being built. First, they created support beams, topped with wood and wire mesh. Then they sprayed the form with cement. There was a bridge from Mount Vesuvius to Robinson Crusoe's Island. The bridge came from a racetrack that had closed. There was also a raft ride to the island. On the island you could see Robinson Crusoe in the cabin with Friday keeping lookout from a tower, and a pen of goats next to the cabin. You could walk around the mountain. It had little alcoves where you could see things like Aladdin and his lamp, but the fifty-foot slide inside was the favorite

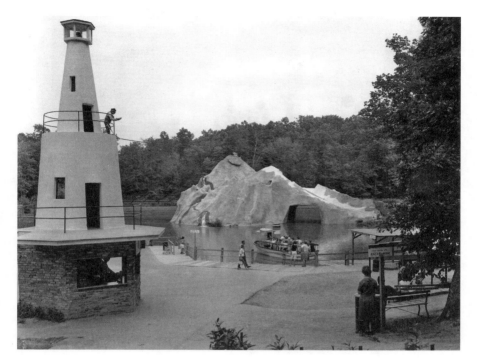

The Lighthouse offered a great view of the lake, Little Toot and Mount Vesuvius. *Courtesy of Linda Harrison Gardner.*

attraction. Kids would climb to the top of the mountain, slide down and then run back and get in line to slide down again—sometimes for hours. There was plenty of seating for parents in that area so they could watch. That slide was the biggest attraction at the Park.

In the summer of 2013, Martha Clark undertook the daunting job of moving the giant slide from the Park to the Farm. It will again be a big favorite for small children.

Goeller had similar memories of this slide, saying, "My favorite rides were Little Toot, the Antique Cars and Mount Vesuvius. The slide in Mount Vesuvius went on forever."

Gardner said, "After Mount Vesuvius, you would come to Snow White's adorable little house. It had little beds for each dwarf, with their names on them and a big bed upstairs for Snow White. All of the woodwork throughout the house was carved in woodland figures—animals and trees. Under the house you could see the dwarf tunnels into the diamond mine

The Teacup Ride took visitors into the Wonderland that was Alice's. *Courtesy Linda Harrison Gardner.*

and hear the music playing—'Off to work we go.' You could look through Plexiglas windows and see the dwarfs working and see the 'diamonds' in the walls. The diamonds had lights behind them to make them stand out. I have several in my home, and they are different shapes and sizes, and different shades of blue. When you came out of the cave, you could look out behind at the pond." The diamond mine included five hundred feet of tunnels.

The Teacup ride enveloped you in the adventures of Alice in Wonderland. The Park brochure said, "See how the adventurous Alice in Wonderland becomes snarled in her many fabulous adventures deep underground. Visit this subterranean fairyland when riding the Teacup Ride to the Mad Hatter's Tea Party and the Court of the Queen of Hearts."

This attention to detail in an age before computer technology is amazing. So much of this detail work was done by hand. Eldridge said:

> *I remember visiting the Enchanted Forest around 1967. I ran to the first cup in the teacup train. I wanted to be the first one to see everything 'til we*

went into the dark tunnel. And, as if it couldn't get any scarier, the ride stopped in the tunnel for us to get out! I remember seeing the scene where they were painting the roses red and the Queen of Hearts looks like she is yelling at Alice. I whispered to my Mum that I was gonna go grab her [Alice] and she could come live with us. My Mum laughed and said they weren't real. They were just like big dolls that wore clothes in the department stores. I remember going home and playing pretend that I was back in Alice's Wonderland and I ran to her and saved her from the Queen. And also in the tunnel, I remember being right on my Mum's heels, by the water. Wasn't it sort of like black light in there for effect? There was a little frog by the edge in the water, and I was sure he was going to jump out at me and push me in.

A child's imagination is a wonderful thing. It's fascinating that so many of these vivid memories linger on so many years later. Cavey said:

The spring of 1964 was my first year old enough to drive a ride, and I was looking forward to all the new things I would be able to do. One of the first rides I drove was the Tea Cup Ride. This was a train ride that looked like a teapot (the engine), and tea cups were for the people to ride in. Between each tea cup was a bench for adults to sit on if they decided not to ride in the tea cup. The engine was a modified lawn tractor. It had no mower of course, and instead of wheels were sprockets with a chain down to the wheels. All you had to do was push a starter button, and the engine would start. It had a preset engine speed, so you then lowered a handle down slowly and the train would start to move. This lever would lock in place, so you then just rode the train around into the rabbit hole and stopped at a certain stop, then stop the engine and go open the gate that would allow the people to enter into "Wonderland." They had a long winding tunnel that they walked through and saw things like the Mad Hatter and the Queen of Hearts. After the people were beyond the gate opening, I would close the gate and drive outside just around the corner to get another load of people. So this was a pretty easy ride to operate.

It is pretty unlikely that the small children and their parents who patiently lined up for the various rides gave much thought to the mechanics of operating them, but you can be sure that the Harrisons and the Selbys did. Gardner recalled:

They built the Alice in Wonderland attraction by digging tunnels with bulldozers, putting a frame over them and covering them back up with dirt.

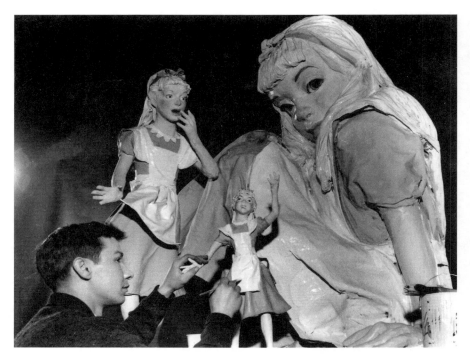

Alice in Wonderland was created in many sizes in Howard Adler's workshop. *Courtesy of Linda Harrison Gardner.*

> *The Teacup ride operated on a train rail—you would go in a tunnel and then the ride would let you off and you would walk through. You could look up and see Alice falling through the White Rabbit's hole. There were fluorescent tears painted on the walls next to a pool of tears and you could hear her crying from a bridge over the pool of tears. There was a magic mushroom that made everything get real big, and then you saw the tea party, with the Mad Hatter and the March Hare and Dormouse. There was music and storytelling there. The cave walls were columns of flowers. The next room had painted roses on the walls, and the Red Queen shouting, "Off with her head." The last room held the trial, with a jury of woodland animals. You came out of the last tunnel at Mount Vesuvius.*

Cavey said:

> *The Tea Cup Ride was up on a ridge overlooking the lake area and the Lighthouse and went around the picnic area. The path up to the ride from the Lighthouse was probably seventy-five to one hundred feet long, and there*

were Sundays that the line for the Tea Cup went from the Lighthouse to the ride and stayed that way for hours. Crowds of people would be waiting for the Jungle Ride to return, and with three trailers—each of which held about thirty people—the ride would fill up in a matter of seconds, with even more people still waiting their turn. The Raft Ride was a very short ride from one pier to another one on Robinson's Crusoe Island. The Raft would hold maybe forty people sitting and had room for twenty to stand. And again a line of people would be waiting for their ride.

Little Toot only held about twenty people and was a pretty long ride around Robinson Crusoe's Island, then it did a figure-eight in the back part of the lake and then through the tunnel of Mount Vesuvius and then we docked back at the main pier. On Sundays as a driver of Little Toot, you never had a chance to get caught up. The rides up on the hill did just as well as the ones at the lake. Lines formed for all the rides and stayed that way all day. This is when the reliever came into play— it was hard just to get away long enough to go to the bathroom. This just gives you some idea of how crowded the Enchanted Forest could be on the weekend. Many people never realized that the Enchanted Forest did that kind of business. Just seeing the small parking lot out by Route 40, and not knowing about the larger parking lot in back part of the Park—which probably held three times the cars that the front lot did—so it seemed nice but not overwhelming. Boy, were they wrong. If the weather was good the Park did very good.

The Raft Ride left the main pier and took a short ride to the pier of Robinson Crusoe's Island where we would let the people off, and they would go into the fort and see how Robinson Crusoe lived. There was a cabin with him in it. (This was just a figure, not a real person.) There were all kinds of things that he would use to live on the island on display around the fort and there was a live goat in a fenced in pen. After looking at the fort you crossed over a bridge that Little Toot would go under when circling the Island. After crossing the bridge you were now on Mount Vesuvius, which was a volcano. The mountain had a fifty-foot stainless steel sliding board that you could slide down, and had a path you could take and return at the top of the slide and slide again and again. It was up to the person how many times you wanted to slide and how long to stay over there. When you decided to leave there was a path that brought you back to the Lighthouse area.

Jungle Land was built after Mount Vesuvius and Robinson Crusoe's Island. Jungle Land had real bamboo and fake animals. The Jungle Ride introduced you to the jungle, where wild animals appeared on every side

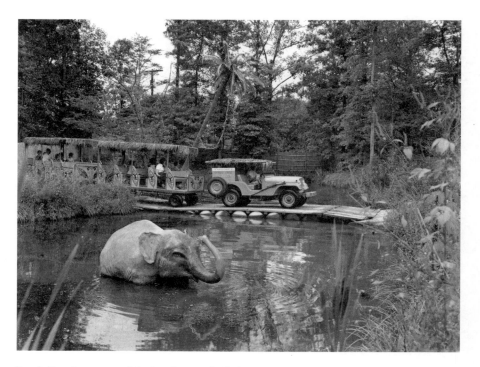

Jungle Land was one of the last features built for the park. The guide did a running commentary to enhance the ride. *Courtesy of Linda Harrison Gardner.*

as you traveled through terrain passable only by jeep. The Park brochure described, "fierce elephants, hippopotami and other wild animals encroach on every side as you travel through murky water to the native village where friendly natives and the witch doctor wait to greet you."

Gardner said, "When my family was developing Jungle Land, Hutzler's Department Store in Baltimore was going out of business. My father bought all of the store mannequins, brought them home and Joe Selby turned them into Jungle natives. The ride was pulled by a jeep, with two long carriages behind it. The person driving the jeep would give the spiel, along the lines of 'Enjoy the adventure—but keep your arms and legs inside because here comes an alligator.'"

Cavey elaborated:

> *The Jungle Ride was a jeep that pulled two—and at busy times—three carts. After loading up with customers the jeep would make a U-turn into the Jungle, crossing over a small moat (this would keep people from walking*

into the Jungle). After crossing the moat your Jungle adventure would start. This is where the speech for the Jungle came into being. The jeep always had a microphone in it but it was never used. So the people riding would find things in the Jungle, kind of on their own. The Jungle Ride was built in the winter of 1963. I remember because it was right after President Kennedy was shot. So its first year open was the spring of 1964. By the time I was given the job of driving the Jungle Ride I would say there were at least three or four drivers before me.

After riding around and around I would kind of get bored with the whole thing, so I decided to put some fun into the ride. As I drove through the Jungle I would think of different things I could say over the intercom that would point out some of the interesting things in the Jungle and try to make it a safari they would remember. At first the people riding the ride were probably thinking I was going nuts, sitting up there in the jeep talking to myself, because at this time I was just trying it out in my head to see if it made sense.

One day I went into the Lighthouse and said to my mother, "When you get you break, before you let the person relieving you go back, come ride the Jungle Ride, I want to show you something." After her break she got on the ride and I started doing the speech I had come up with. After returning, she said that it really added something to the ride. Not telling me, she called Uncle Joe and asked him to come down to the Lighthouse, that there was nothing wrong but she just wanted him to come down. So he did, and she said ride the Jungle Ride and let Norman show you something. Mom came over to the ride and said, "Show Joe what you showed me." After riding the ride he said, "Norman, do that from now on and teach it to all the others who drive this ride. I want them to do it as well." So that was the start of the Jungle speech.

The first year of the Jungle Ride was the spring of 1964. My first year to drive rides was 1964 but I didn't drive the Jungle Ride until 1965, so the ride went a full season without a speech. That first year at the lake I drove Alice in Wonderland and the Raft Ride. The following season I learned Little Toot and drove the Jungle Ride the most of the four. I was then able to relieve drivers on all four rides at the lake.

When I decided to film the Park in 1987 just before it closed, I was filming the Jungle part and was back in the Jungle with my movie camera which was huge then (you put a VHS tape in it). The Jungle Ride came into the Jungle and I could hear the driver saying the speech. Well the speech this person was saying—except for just a few small changes—was

the same I had said twenty-two years before, which is amazing when you realize that it was never written down. It was just told to each new driver as part of learning the ride.

So after doing this speech for hundreds of times, let's see how much I can remember:

"We are now entering into 'Jungle Land' (as you cross through the moat of the jungle entrance). As we enter into the Jungle the first animal we come upon is a large grey hippo on the left. We are now riding by a baby elephant taking a bath while its mother watches over it for protection. Watch out! There is a lion on the left. Keep an eye on those alligators we are passing there on the right. We are now being greeted by the chief of the village. And now we are being greeted by the village Witch Doctor. (These two figures are ones that were stolen and never replaced.) Watch out! There's a rhino on the right!

"We are now crossing over this river and into a native village. You will notice that the people of this village built their houses on stilts. This is to keep them safe from the wild animals of the jungle and also to keep out the sometimes rising waters of the river during the rainy season. The large building in the center of the village is the home of the Witch Doctor, who is the most powerful person of the village. The painted coconuts on poles and the paintings on the Witch Doctor's house help keep out the evil spirits from the village. The natives here on the right are carving out canoes from logs, which they will use to catch fish and to go downriver to trade with the missionaries.

"We are now leaving the native village and crossing over into the most dangerous part of the Jungle, so keep an eye out for wild animals that might attack! Watch out! There's an alligator attacking on the left! (This alligator was about twenty feet away and would start out on top the water then dive down and come up right in front of the hippo.) Watch out, hippo! (This was said right before the alligator would rise up, looking like he was opening his mouth. At this time, you would take out your starter pistol and shoot at the alligator right when it would stop.) Watch out! Here comes another 'gator! (Again shooting your gun. This gator was underwater and would come up right at the side of the cart and open its mouth, doing this to each cart as we went by. The cart was also going through the water, which was about a foot deep.) Watch out! There is a python in that tree; they are one of the most deadly snakes of the jungle! Watch out! Another alligator is on the move to our left. He looks like he's after those monkeys hanging from that vine. (We knew the timing of things that were going to happen. Right

before the monkeys would rise up on the vine hanging from a palm tree over the water you would say: 'Watch out monkeys! There's a 'gator coming up behind you!' (At about that time the monkeys would go up the vine, and the people would usually get a laugh out of it. Again, you shot your gun just as the alligator stopped, and the hippo opened his mouth like the first one did.) We are now leaving the Jungle and returning to civilization. I hope you have enjoyed your safari through Jungle Land, and have a great day here at the Enchanted Forest. Thank You."

Cavey went on to say, "The next attraction down at the lake area was Huck Finn's Fishing Hole. This was built sometime around 1976 and would have opened spring of 1977. Huck Finn's Fishing Hole was a man-made pond that had fish swimming in it. It was a catch and release. You were given a certificate if you caught a fish in a certain time period. So the job of the operator was to unhook the fish caught and hand out certificates and be a time keeper."

The most memorable part of the Park was the Storybook Land of Fairy Tales, with Cinderella's Castle the premier destination. This castle came to be the symbol of the Park. Gardner said, "Cinderella's Castle was designed by Joe Selby. To get to it, you would ride in the pumpkin drawn by white mice to the foyer of the Castle. Each of the six mice was at least ten feet long. Inside, you could see Cinderella on her knees scrubbing the floor, accompanied by her mice friends. Up on the next level were animated figures, including Cinderella, dancing at the ball. Up another flight of stairs you saw the Prince trying the glass slipper on Cinderella. The top of the Castle was the house where they lived happily ever after." Also in Cinderella's Castle were trompe l'oeil busts painted on the Prince's ballroom walls.

Cavey recalled:

Because of the size of the Castle and the ride, construction was started during the summer when the Park was still open, just to make sure it would be ready for the following spring. I had the opportunity to work on this attraction because I graduated from high school in June 1966. Cinderella opened spring of 1967.

The Cinderella's Castle attraction had a ride that consisted of six white mice pulling a pumpkin. Two of the mice were the engine, and that was where the driver drove the ride from. The other four mice made up two carts that would hold maybe twenty people in each one, and the pumpkin coach held about fifteen to twenty people. This ride drove people to Cinderella's

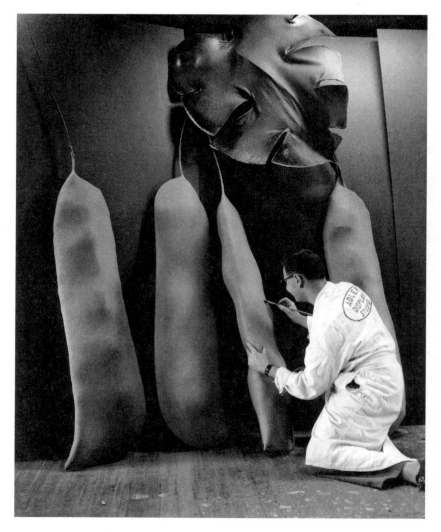

The beans for Jack's Beanstalk were very large indeed, and each was carefully crafted in Howard Adler's studio. *Courtesy of Linda Harrison Gardner.*

Castle by going down into the Enchanted Forest's oldest section where the fairy tale characters lived. You would pass by the back of the Three Bears' House on your right, the Good Fairies' Tree House where Sleeping Beauty grew up on your left, the Little Red School House on your left, the pond with Three Men in a Tub and Willie the Whale on your right, Jack and the Beanstalk on the left and Humpty Dumpty next on the left.

Then you would go by the front of the Three Bears House on the right and go up the hill behind the Gingerbread House and into the moat of the Castle. This is where visitors were dropped off. After dropping people off, the driver would drive out of the moat and back to the staging area and load up for another trip around. The visitors to the Castle would then see scenes of the story of Cinderella on three different floors of the Castle. After they finished touring the Castle, they would exit on the main floor.

The Park brochure described the Ali Baba and the Forty Thieves feature as "an exciting water ride through Ali Baba's treasure cave in boats that glide by tableaux from this fantastic Arabian Nights story." It was composed of twenty-six three-dimensional figures, of which fourteen were animated. Gardner said, "Ali Baba was one of the last attractions built. It was built by Joe and Bradley Selby and Norman Cavey. They used braces, wood and chicken wire, then sprayed that with cement. The boats passed over a moving water wheel that kept the water constantly moving. My father decided that was too dangerous, so they had to find another way to keep the water moving. I didn't like this attraction as much as the others because the scenes in it were scarier."

Cavey also remembered this same attraction:

We started building Ali Baba's Magic Mountain in the fall of 1970. This attraction took most of the area that they had used for the live deer and peacocks and other small animals for people to look at. This attraction was a low-height mountain that had a moat running through it. The ride itself consisted of boats shaped like treasure chests that would float through the mountain and the people would see scenes of the story of Ali Baba and the Forty Thieves. The operator of this ride had a fairly simple job. There were two handles that controlled the treasure chests, one would release the next boat to go into the mountain and the other would stop the chest coming out of the mountain so the people could get out.

Also, after the Park expanded behind the Gingerbread House, we found that people weren't spending as much time in the front of the Park as we hoped they would.

That changed with the Circus in Central Park (which was a miniature circus that took a Frederick engineer ten thousand hours to construct and was made up of one hundred thousand pieces). Gardner said, "One night a man knocked on my parents' door. He had a bus filled with circus scenes that

he had made himself and asked if my father would be interested in buying it. The workmanship was meticulous—all handmade. My father bought it on the spot. To house the circus, we built a tent that looked like free-flowing canvas but was really cement. There was a miniature merry-go-round and a Ferris wheel in the circus display, and we sold cotton candy and soda in the concession part of the building."

Cavey said, "The Circus Tent was built in 1969–70. This was more of an attraction/concession stand. The attraction was a scale model of a circus with all the major rides working and lit up. This was on display in the back of the tent, behind glass, and you could walk around and look at all the detail of each circus ride. When you came out the other side, there was a concession stand in the front of the tent selling snowballs, cotton candy, popcorn and fountain drinks. This was the only place in the Park you could get snowballs or cotton candy. The concrete work on this was amazing. It really looked like a circus tent."

When the Park expanded, Robin Hood's Barn became a snack bar as well as a site for ticket sales for people coming in from the back parking

Young drivers take to the road at the Antique Car ride. *Courtesy of Linda Harrison Gardner.*

lot. On the lower level was an animated computerized show called "The Chicken Little Orchestra." Cavey said, "The last attraction to be built was the Playhouse in the Barn Starring Chicken Little. This attraction was built after Uncle Joe died—he never saw this attraction finished. It was located under Robin Hood's Snack Bar and Gift Shop. This was a ten-minute show with animated figures of animals singing and playing instruments. It had theater seating, and the operator took tickets and started the show."

The Antique Car ride, added in the 1960s, allowed young drivers to test their skills on a hilly, curved speedway. Gardner said, "When Millard Tawes was governor, he used to bring his grandchildren up to spend the day at the Enchanted Forest. They liked the car ride so much he asked my father to order an extra car for them, and my father had it delivered to the Governor's Mansion in Annapolis."

Chapter 7
Working at the Park

In Season

The Enchanted Forest was different from most places of employment in that the majority of employees working when the Park was open for visitors were teenagers. That meant that adults like Midge Cavey, Joe Selby and the Harrisons had to keep an eye on the young employees along with doing their own jobs. There were a lot of rules but also a lot of fun.

Gardner said, "The kids who worked at the Park had to be on their best behavior—they had to be unfailingly polite and they had to abide by the dress code of Enchanted Forest—tee-shirts and clean jeans with belts—that is, for those who weren't acting as storybook figures." Cavey elaborated, "The Jungle Ride was the only ride at the Enchanted Forest where the driver wore a costume. All of the other drivers wore their own pants, shorts or jeans and an Enchanted Forest tee shirt. Usually all of the shirts worn by the drivers were the same color. The Jungle Ride driver wore khaki shorts or pants with a khaki shirt and a pith helmet. He sometimes wore a holster with a starter pistol in it to shoot the alligators with. After a period of time, I think this went away and the driver of the Jungle Ride looked like the other drivers."

Gardner said, "My father's sister, Thelma Hunter, made all of the storybook figures' outfits in the early years. Hers were very fancy and frilly."

According to Cavey, "The girls in Robin Hood's Barn who worked in the snack bar wore green shorts and orange shirts with a green Robin Hood's hat with a feather in it. Girls in the gift shop wore outfits like Old Mother Hubbard, and they looked much the same at the Castle. Girls who worked in the upper ticket booth and in the Circus Tent wore the same thing as the

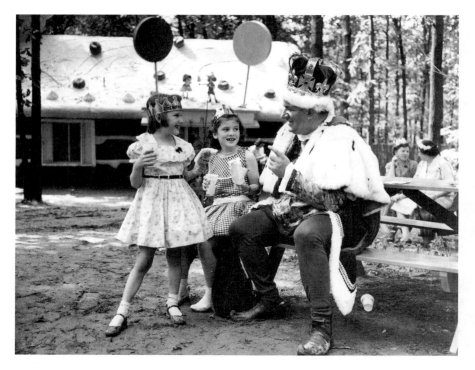

Old King Cole was one of the many fairy tale characters who roamed the park and delighted the visitors. *Courtesy of Linda Harrison Gardner.*

girls in the snack bar. My mother in the Lighthouse usually wore white slacks and a top that reminded you of a sailor. As maintenance workers we just wore our own clothes. We just looked like the customers."

All four of the Harrison children worked at the Park growing up, and eight of their children also participated. The family worked fourteen- to eighteen-hour days during the season. Local high school students were enlisted to do a variety of jobs around the Park. They tended to the landscaping, directed traffic and drove the rides. The Park employed close to 150 people at any given time.

Gardner said, "There were several Enchanted Forest romances that led to marriage. I can think of Chris Bobo and John Lederer, Dave Miller and Ann Feaga and Bonnie Bolger and Henry Richard Wainwright III. Bonnie was my cousin and was just fourteen when she started working at the Park, playing Little Red Riding Hood. Henry was sixteen and dating Little Bo Peep but found he was more interested in Little Red Riding Hood. Four years later, in 1960, they were married."

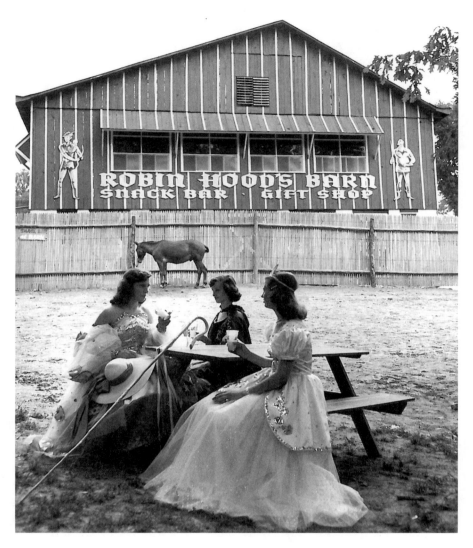

Mary King as Bo Peep, Mary Alice Raphel as Little Red Riding Hood and Doris Todd as Cinderella take a break in the picnic area next to Robin Hood's Barn. *Courtesy of Linda Harrison Gardner.*

Charles Feaga said, "When the Enchanted Forest was built, I was running a large dairy farm operation that took up my time seven days a week. During World War II, we had German prisoners of war who helped work the farm, but after the war we lost that help. My two sons worked with me on the

farm, but my five daughters all worked at the Enchanted Forest. Joe Selby was the manager then, but the Harrison family was very hands-on, actively participating in the running of the Park. Buddy Harrison told me he wished I had more daughters to come work at the Park."

Cavey said:

> *Growing up and working at the Park was a great time in my life. Being an only child I liked working with others my age. That is what was so special about the Park—the kids outnumbered the adults. So it had a different feeling working there. You weren't the only kid working among all these adults. Plus, the adults who worked there were friendly and didn't put you down. They knew that this was most likely the first job you had had. The work wasn't hard but sometimes the hours were long. We were interacting with the public, learning to give change back—I think today that if cash registers didn't tell kids the amount to give back they couldn't do it. Back then most of the cashiers had cash boxes and ticket sellers had to check out evenly, with the number of tickets sold matching the amount in the cash box less the amount you started with, which was usually forty dollars.*
>
> *When I first started working at the Park in 1961 I was thirteen years old. Being thirteen I needed a work permit from my doctor to get a job back then. I don't know if it's like that today or not. My starting salary was seventy cents an hour. We were paid every week in cash. I think after taxes I got about ten dollars when I worked only weekends and probably around thirty dollars for a six-day week. Being in school at the time I got back most of what I paid in taxes, so it was like money in the bank.*

Gardner remembered, "The workers put bumper stickers on all of the cars, but if people didn't want them they would take them off. The early ones were made of cardboard, attached by wires at either end, so they were easy to remove. Repeat customers knew to tell the kids right away if they wanted them or not."

Goeller added, "I remember how crowded the parking lot would be, and how on summer weekends the traffic would back up on Route 40 and they would have police out directing traffic. They managed to park the cars in really straight lines, and it was so cool to come out of the Park and find a bumper sticker on your car."

Cavey told us:

> *We maintained a lot on the corner of Route 40 and Bethany Lane, which is where M&T Bank is today. We used this lot during the summer when*

crowds were so large that we would run out of places to park them, so we would use this as an overflow lot. We even had Sundays that were so busy that we had people park in front of the businesses that were on Bethany Lane, and they would walk up Bethany Lane and down the side of Route 40 to get to the Entrance Castle. On Sundays, the crowds were so large that it would take sometimes five or six people to get traffic to flow to the area you were parking.

Toward the end of each day the Park was open, someone would drive a tractor around the Park. It had a large cart behind it with running boards on the sides. We stood on the boards and rode around the Park emptying trashcans into the cart. Then we would take the cart out to the back corner of the parking lot, where there was a cinder block building shaped like a "U" that had walls about eight feet high and no roof. We would back the cart into the building and shovel the trash out and then light it on fire. We then had to stand there for about an hour to make sure the fire stayed under control. This didn't last long before the fire department and the health department put a stop to open burning. So then we had a dump truck in the woods that we could back up to and shovel the trash into. We then drove the dump truck to the landfill and dumped it. The amount of trash was amazing—on some Sundays we could fill that truck up completely.

There was a lot of behind-the-scenes work that went into keeping the Park running smoothly. Workers had to come in before the Park opened and stay after it closed to make repairs, touch up paint, mow the vast expanses of grass and keep things clean. Cavey continued:

Someone drove a golf cart around the Park at the end of the day, picking up the two ladies that worked at the Castle entrance and bringing them back to Robin Hood's Barn to check out. They would turn out the lights in the Castle that lit the buildings at that end of the Park. The ride on the cart also kept employees from having to walk through the Park with cash drawers full of money.

Uncle Joe also had the job of overseeing the full-time employees. Our job during the time the Park was open in spring, summer and fall was to keep everything clean, in good running order, and to maintain the Park—to see if something needed to be repaired or painted. If a ride broke down, we'd get it up and running as quickly as possible. A downed attraction isn't making any money. We'd fix it as best we could and later that evening or the next morning before the Park opened we would repair it properly.

We didn't wear name tags, and one time Uncle Joe was in the back room where the kids would wait for him to come in and give them their assignments for the day, and this particular day he came in and pointed to one of the employees and Uncle Joe stood there trying to think of his name. After a short period, Joseph (his son) said to his father, "Dad, his name is Larry"—who was his other son. We just cracked up because he had so many names to remember, he just went blank.

Time and again, people remembering the Park in its prime refer to the true family atmosphere it exuded. While the Selby and Harrison families were the backbone of the Park, all of the employees were treated with the same warmth and generosity—a feeling that spilled over to envelope the visitors.

The Park usually opened for the season on weekends only on or close to April 1 or Easter, whichever came first. It was open seven days a week after May 15. The full-time employees worked seven days a week until the school kids who were going to work the Park got out of school. Then we worked six days a week—and your day off was never Sunday, that being a busy day. When the kids went back to school, even with the Park being open only on weekends, we worked seven days a week until the Park closed and everything was put away for the winter.

As everyone knows who has ever been to the Enchanted Forest or even seen postcards that there was a lot of flowerbeds throughout the Park with hundreds and hundreds of annuals planted each year. Probably no one has ever thought about how they got there and their upkeep.

It was Uncle Joe's rule that no annuals were planted before May 15. That seemed to be when you didn't have to worry about Mr. Frost anymore. We used local nurseries like Whitakers. We planted hundreds of flats of annuals every year. The biggest problem with the flowerbeds was watering them. Because Uncle Joe was usually the last one to leave the Park each night (being the one who closed everything), he would be the one to water the flowers before going home. This took quite a bit of time, considering the number of beds and that they were all around the Park. This involved dragging hoses everywhere, hooking them up and then putting them away.

It's hard to imagine the amount of hands-on work that had to be done to keep the Park attractive and the amount of resourcefulness that went into creating the logistics needed to do things no one had ever done before. Cavey continued:

Then came the sprinkler system. This was installed in the late 1960s, so you can see that watering the flowers by hand was done for years. The sprinkler system was something that had needed to be well thought about because of the risk of freezing water pipes and getting water to different parts of the Park without damaging trees and paths.

Anyone who has ever put a shovel in the ground in Maryland knows it won't be long before you hit a rock in the ground or a tree root. The main line for the sprinkler system started at the Jungle Land Safari Ride entrance. Looking at the entrance from the front, the building on the right side of the moat is where the pump for the system was located. This pump was about the size of a Volkswagen bug and ran on electric power. It was so big it had to be installed inside the building in pieces to get it through the door. The line coming out of the lake to the pump was six inches in diameter, or possibly bigger, and so was the first sections of pipe leading up into the section of the Park where the original buildings were. The main line came out of the entrance and made an almost ninety-degree right turn and went under the road for the Jungle Ride and then ran behind the Lighthouse and up to the Park. Between the Sombrero and the swings that were next to Humpty Dumpty was the first set of valves to run the water off into different directions through the Park. This was also a low area that was used to drain the water lines so that they wouldn't freeze in the winter. One of the lines ran behind all the buildings lining the Three Pigs side of the Park, so this would also be behind the Easter Egg, the Crooked Man's House, the Beanstalk and Humpty Dumpty, and then turned and ran parallel along Route 40 and across the parking lot to Mr. Harrison's lawn. This made this line probably 1,500 feet long or more. There was a line that ran up the middle of the Park and one along Red Riding Hood's side of the Park. All along these lines were areas to drain the system.

The first time the system was turned on, we learned a few things. Because this pump was so powerful to get water uphill and all the way to Mr. Harrison's house, the first time it was turned on, at the almost ninety-degree bend in the pipe just outside the Jungle entrance, the force of the water blew the pipe apart and before we could turn it off, it blew out about a six- or eight-foot-long trench of the lake shore line, about three feet deep. In order to keep this from happening again, we had to pack about half of a cement truckload of cement around this pipe so that it wouldn't move. We also learned you had to be certain you had enough sprinklers turned on or the water pressure would blow sprinklers out of the ground.

A lot of work was put into running these lines. Whenever we came upon the roots of a tree, we would dig under them by hand to make sure we didn't cut them and take the chance the tree might die. Because we were trying to grow grass in the woods, where it didn't get a lot of sunlight, we were always fertilizing and seeding. The grass would barely grow. The sprinkler system helped quite a bit.

This system was using so much water that we had to keep the waterfalls on Mount Vesuvius on or the water level in the lake would go so far down that Little Toot would hit bottom at certain places in the lake. Water for the waterfalls was pumped from the stream that ran parallel to the lake. When we knew we were going to use the system that morning or night, we would leave the falls on. You never had to worry about putting too much water in the lake because it had an overflow pipe at the far end of the lake that would maintain a certain height. The overflow would return water to the stream. This is the same stream you crossed going into the native village in Jungle Land.

The person who taught us how to operate the rides was usually someone who had operated it before us. Back then most of the cars we were driving at the time were not automatic transmission, so operating a ride with a clutch was not a problem. Years later, teaching kids to drive these rides became difficult because they only had experience driving cars with automatic transmissions. They would jerk those rides to death until they got used to the clutch. Guys driving the rides had to deal with parents and kids who after standing in line—sometimes for twenty to thirty minutes—weren't the friendliest people to be around, but you grin and bear it.

When you were old enough to operate a ride, you were taught to drive all the rides, so you could be a reliever when someone needed a break. Not all the guys could drive all the rides— it was usually someone who had been there more than one season. It seemed like the more summers you worked, the more responsibility you were given. It's funny, but it wasn't until the last couple of years the Park was open when girls started operating rides. Why that was, I don't know, but it was.

Young ladies were a part of the Park from the beginning, just not operating the rides. The plum jobs were those of the fairy tale characters like Little Red Riding Hood and Little Bo Peep, but others served in Robin Hood's Barn, dressed in outfits and caps like Robin Hood's. Cavey disclosed:

For some reason, drivers always started working the rides that were what we called "On Top of the Hill." At the time, these were the Antique Cars and Mother Goose, with the Cinderella Mice Ride coming in 1967. The next season you worked you were promoted to lake rides, and you got a ten-cent an hour raise. So now you were making eighty-five cents an hour, and you were the cool guys who worked where everyone wanted to work in the Park—down at the lake and not "on the hill." When I went to the lake in 1964, the rides there were the Raft Ride, Alice in Wonderland, Little Toot and it was the first season for the Jungle Safari.

As a schoolkid working in the Park, and working for the number of years I did, I worked every ride in the Park. I also cut the grass before the Park would open in the morning. This was a big deal because of the amount of grassy areas the Park had. There would be ten to twelve of us trying to get all of the grass cut—including Mr. Harrison's lawn—before the Park opened in the morning. This was usually done on Friday and Saturday mornings so the Park would look its best for the busy Sunday crowds.

We had to keep the buildings clean during the season. The roofs of the buildings were hard to keep nice-looking all year long, since they were in the woods. Several times a year, the roofs would be washed in the morning, early before the Park opened for the day. Kids working at the Park would be asked to come in early to help with the washing of the roofs. The way we washed these roofs, today OSHA would have had a fit. The roofs of the Merry Miller's House and the Circus Tent were just a couple of attractions that were washed many times during the year. We used liquid soap and water, push brooms and scrub brushes so the roof would get very slippery to walk or even stand on. One time one of the kids washing the Merry Miller's House fell off the roof into the pond next door. Seeing this made us laugh, but then we'd stop and wonder if he was okay. [He was.]

There were poles that came up through the roof of the Circus Tent, just like the ones used to raise real canvas tents on (the Circus Tent was made out of concrete). One of the kids tied a rope around one of these poles and rather than holding on to the rope with one hand and scrubbing with the other like we all used to do, he decided to tie the rope around his waist. Well, it wasn't long before he slid down. The problem was that the rope was just long enough that his feet were about twelve inches off the ground. It's a wonder he didn't cut himself in half, but it was funny to watch. Everyone, including myself, slid off of a roof at one time or another.

Another family member who worked at the Park was my Uncle Bradley, Uncle Joe's brother. He was the main mechanic. He was responsible for

maintaining the rides—repairing them when they broke down, gassing them up each morning, checking the oil and tires and so on. During the winter, he would service them by sometimes removing the engines and rebuilding them to make sure they wouldn't break down during operating season. He was also responsible for plumbing and electrical repairs throughout the Park. He was a jack-of-all-trades and was very good at getting rides that broke down during operating hours to run again. He'd use his belt, a paper clip, duct tape or a piece of rope—anything—to keep the attraction working until the Park closed, then fix it the right way. I became his assistant when I returned from the army in April of 1971 and worked beside him until I left in February of 1977. I learned a lot from him about mechanics, plumbing and electrical work. When I came back to the Park, Ali Baba's Magic Mountain wasn't open yet and that's the first ride I worked on after the army and was considered a full-time employee. That ride didn't open until May of 1971 because they were still trying to get the water to circulate.

After Uncle Joe died, in 1981, Uncle Bradley became manager of the Park along with his wife, Marlene. Aunt Marlene helped mostly with getting the girls assigned to what position they were going to do for the day and getting them relieved for lunch and bathroom breaks. Uncle Bradley worked with the boys and continued to do the maintenance work along with the management. This is why he needed the assistance of Aunt Marlene while Uncle Joe managed the job alone. Until becoming assistant manager with Uncle Bradley, Aunt Marlene's job was to operate the rear entrance and gift shop, which were in Robin Hood's Barn. She was there for a long time. She also helped the Harrisons pick the souvenirs to be sold in the gift shop. Every fall Aunt Marlene and the Harrisons met with salesmen to purchase sale items. She also helped determine the quantity of merchandise to buy based on what was sold the year before.

Goeller said, "They had so many kinds of souvenirs in the gift shop, like flags and hats." Bell added, "I still have the Enchanted Forest wallet my son Scott bought at the gift shop decades ago."

Cavey noted:

My mother, Mildred Cavey, worked at the Park for over twenty-five years, from 1961 to 1986. Everyone who worked at the Park knew her as Midge. She worked at one place only—the Lighthouse on the lake. She was the first person to work there when it opened and the only one until she got sick and could not work anymore. The only other people who worked there did so on

Evelyn Myers, Marlene Selby and Midge Cavey worked at the Enchanted Forest for many years. *Courtesy of Linda Harrison Gardner.*

her day off, which was always Friday. I think she took that day off to rest up for the busy weekend to come. With the rides at the lake being so popular, it wasn't uncommon for her to work without lunch or breaks. The Lighthouse was where visitors could purchase tickets for the rides as well as popcorn, sodas and ice cream sandwiches. She was also the unofficial boss of the lake area. She always made sure the guys running the rides kept their rides clean, the grounds around their rides clean and that they didn't fool around. Uncle Joe and Uncle Bradley had very few worries about the lake area.

Gardner remembers, "Norm's mother kept wax paper in the Lighthouse. She would see kids having trouble getting down the slide in Mount Vesuvius, and she would send someone over with the wax paper to give to the kids to slide on."

Cavey told the story:

We used to wax the sliding board on Mount Vesuvius with a piece of wax paper. You would sit on it and ride down the sliding board. This would make it slippery so you would go down with no problem. Well, we might

go down once or twice and this would make it work fine. BUT, when you went down maybe ten or twelve times, people would fly down that sliding board and land on the thick mat they had at the bottom. It was really funny to see them come down so fast.

When I was around sixteen years old—which would have been the 1964 season—Uncle Joe in the summer months would go home for dinner around, I think, 5:00 p.m. Because it didn't get dark until 8:00 p.m. or later back then, the Park would stay open until almost dark. Sometimes the Park didn't have many people in it, and when Uncle Joe would leave for dinner, we would get in the Antique Cars and drive them all around the Park. This was before Ali Baba's Magic Mountain was built, and there was a chain-link fence you could see through to the parking lot, so you could see him leaving and when he got back.

It wasn't all fun and games, however.

Probably the biggest headache the Enchanted Forest had was vandalism. Over the years, the Park lost thousands of dollars due to damaged and stolen items. When you look at some of the postcards or pictures of the early years of the Enchanted Forest, you'll see figures like the Crooked Man and notice he doesn't look the same in later pictures. This is because the first Crooked Man was either stolen or destroyed. This happened to many of the figures in the Park: the Three Pigs, kids from the Old Lady in the Shoe, Hansel and Gretel from off the Gingerbread House and Natives from the Jungle Ride, just to name a few.

In the Seven Dwarfs' House, two large pieces of glass in front of the beds of the dwarfs were broken on a Saturday night and it was impossible to replace them for the Sunday crowd. Mirrors on the rides either had broken glass or were broken off completely. Two of the large figures in the Jungle—the Chief and the Witch Doctor—were stolen and because of the cost were never replaced. Two or three kids in the Shoe were stolen and never replaced but there were still four or five there. The Tortoise and the Hare were broken up to the point that the figures you saw in the Park in later years weren't the same as we opened with.

As Howard County grew up around the Enchanted Forest, this problem got worse. What used to happen occasionally became for a while an every-weekend event. When the kids were out for the evening on the weekend and looking for something to do, the Enchanted Forest was the place to go. The traffic around the Enchanted Forest later in the evening was reduced to almost nothing, making it easy for kids to jump the fence and have a ball running around in the Park. With nothing better to do while they were in the Park, they would start to break things up.

Visitors made donations to the Wishing Well, which were then passed on to charitable groups. *Courtesy of Linda Harrison Gardner.*

Another big thing to be vandalized was the Wishing Well. This Wishing Well was at the front of the Park between Little Miss Muffet and the Merry Miller's House. Money that was tossed into the well was donated to a crippled children's fund. More times than you can count this was broken into at night and the money stolen. It got to the point that it needed to be emptied almost daily. We liked to keep a little money in there because it would draw people to add to it more so than an empty well.

Vandalism continued to get really bad while I was working at the Enchanted Forest full time, between 1971 and 1977. There were nights that we would hide in the Park—usually Friday and Saturday nights—hoping to catch some of these people breaking in. We even went to the expense of installing intercoms in the Lighthouse and the Gingerbread House, which were two buildings that were being broken into the most. Bruce Harrison and I would be listening in the office at Robin Hood's Barn, hoping to hear someone trying to break in. This didn't help—we never caught anyone. We would walk the grounds at night, seeing if we might walk up on someone in the Park. One night we were in the Park until about midnight and nothing happened, so we decided to go home. About a half-hour later Mr. Harrison, who lived on the property, heard voices and laughter coming from down in the Park. He called the police, who caught about twelve people from a motorcycle gang coming over the fence. I'm glad we went home that night because we probably would have been beaten up.

One Sunday I was home—on the Enchanted Forest property next to Bruce's house, and Buddy Harrison called. He had stopped at his parents' house for a visit and while getting out of the car out of the corner of his eye he noticed two boys down in the Park headed toward the lake. Buddy went into the house and called Bruce and me and told us to come into the Park from the back, which we could do from where our houses were, and that way we would trap them. By the time we got to the edge of the lake, the two boys had seen Buddy and decided to make a run for it. They thought that Buddy wouldn't chase after them if they jumped in the water and crossed the lake. Well, Buddy—suit, tie and all—went right in behind them. Bruce and I were waiting for all of them on the far shore and just laughing and laughing at Buddy. If he had noticed us just a second before he jumped in, he would have known we would have gotten them. This all happened in the winter, and the water was next to freezing. That made it even funnier. Because of the temperature difference when Buddy and the kids got out of the water the steam was coming off them like they were on fire.

Working in the Park in season had many challenges and many rewards. It must have been gratifying to see the long lines patiently waiting to ride the Teacups or the Jungle Ride. Just seeing a young child's eyes light up when greeted by one of the costumed characters or recognizing the pride generated by successfully navigating the Antique Cars must have made the job a special one.

Working at the Park

The Off-Season

After the Park closed for the season, the work continued. Most of the teenagers returned to school, but for the full-time employees, the jobs continued to challenge. Most years, new attractions were added, so there was design and construction to accomplish. Just the mere fact of many tiny hands lovingly touching the Pumpkin Coach, for example, meant lots of cleaning and painting. The weather wasn't always a friend, either, and attractions had to be restored and repainted. The off-season did offer some quiet times, too, when workers could enjoy the atmosphere of peace without the constant crowds.

Cavey described the off-season work schedule:

> *During the off-season, we closed the Park by removing all the figures that were manageable and storing them in Robin Hood's Barn or the maintenance building. We winterized the Raft Ride and Little Toot by checking antifreeze in the motors and securely chaining them to the piers. We would lock all the building doors.*
>
> *Mr. Harrison always wanted the Enchanted Forest to look like it did the first year it opened. Almost everything in the Park was painted as soon as the weather would allow. Some years, when Easter was early, it was hard to get everything painted, with frost and even snow still on the ground. With everything being in the woods, the dirt from the trees just turned everything black. Building roofs would be hosed down and brushed as clean as possible, and then Uncle Joe would determine if they needed to be*

*painted. Sometimes because of the freezing and thawing we would not only
have to paint an attraction but we would also have to repair it first.*

*It was very important to Mr. Harrison that the colors of the attractions
remain the same. We couldn't just paint something a different color because
we thought it would look nice. Mr. Harrison could even notice if the shade
of the paint had changed. We used oil-based paint on everything, inside
and out. One time we painted the playground equipment right at the very
last chance we had before the Park opened, because of frost. Mr. Harrison,
who walked the Park all the time, noticed that the shade of red we used was
off a little bit—it was more toward the orange side of red—and insisted
that it be repainted right away. With the cold mornings and dampness of
the weather, it just wouldn't dry, and so when the Park opened we not only
had wet paint signs posted but we also had to stand in the playground
all day to make sure none of the kids or their parents touched the damp
playground equipment.*

*Over time, the flavor of the ice cream in the cone on the Gingerbread
House changed from vanilla to chocolate. This was not an easy change.
Uncle Joe wanted to change it because the vanilla was difficult to keep
looking clean—the chocolate was easier. Well, it took a major meeting to get
that changed, but eventually it happened.*

It's interesting that while Howard Harrison Jr. had very fixed ideas about
how he wanted things to be at the Park, he was also open to improvements.
Vanilla ice cream morphing into chocolate seems like a very good idea—a
real work-saver for his staff, so they could concentrate on more important
upkeep. Cavey shared:

*Another attraction that needed constant maintenance was Mount Vesuvius.
I believe that from the time that mountain was built to the closing of the
Park, that mountain was always slowly sinking into the lake. Basically,
at first the lake area was just swampland. The lake was man-made,
and so were the islands. The main part of the mountain sat on a small
man-made island. Inside the mountain were cinderblock walls with wood
framing to shape the mountain and walkways. Those cinderblock walls
also supported the fifty-foot-long sliding board that was the main attraction
of the mountain. Not only was the weight of the mountain pushing it down
into the swampy area around the island but also the freezing and thawing
of the ground made large cracks in the mountain, and even pieces of the
mountain fell off. Every few years, more cinderblocks were needed to support*

more areas under the mountain. One measure of how the mountain was sinking was Little Toot's smoke stack. Every few years we would have to cut a few inches off of the smoke stack in order to keep it from hitting the roof of the tunnel. It got to the point where the smoke stack was the same height as Toot's head. At the end of the Enchanted Forest's run, Little Toot could no longer go under the tunnel because even the head would hit it by then.

Inside Mount Vesuvius was a chimney that was used to make Mount Vesuvius look like it was getting ready to erupt—white smoke would be coming out of the top of the mountain. There was a concrete-covered doorway that matched the exterior of the mountain that let us go inside. We would have to use a small rowboat that we kept out of sight in Jungle Land. After we rowed over, we would find the chimney, and at the base of that chimney was a small Briggs & Stratton motor similar to what a lawn mower would have. The motor was positioned so that an extension of the muffler would go into the base of the chimney. On a pole next to the chimney was hanging a five-gallon container for kerosene. This had a thin copper line running down to a hole in the muffler. There was a lever at the beginning of that line that we could use to control the amount of kerosene that would run into the muffler. The heat from the muffler was just hot enough to burn and turn it into white smoke, and the air coming out the muffler helped blow the smoke up the chimney. The motor had an oversized gas tank, which made it run from about 10:00 a.m. to about 5:00 p.m. each day. We would go over to the doorway once a week to get stocked up with more kerosene and gas. We would have to take the five-gallon kerosene cans to the Southern States Petroleum Store that was across the street from the Park. Then we would take the five-gallon gas cans to Cornell's service station, which was also located across the street. These two businesses were located where the Double-T Diner is now. I can't remember when they stopped doing this, but it was before the Park closed.

The maintenance involved in keeping Mount Vesuvius operating was daunting indeed. Secret doorways and gas runs were part of the ongoing operation of the Park that the public never knew about. Cavey continued:

Another example of the effect of freezing and thawing on attractions is Jungle Land. The water that the alligators and hippos were in would freeze and thaw, and the track that the alligators rode on would rise up and sometimes be above the level of the water and could be seen. So, we would have to go in and use sledge hammers to beat them back down. Also, the

cables that operated the alligators and hippos would be changed to ensure that they would not break down during the season. Uncle Bradley was amazed that he could hold a nail under water and hit it with a hammer.

One of the things Uncle Joe feared the most in the Enchanted Forest was people in the Park during a thunderstorm. His fear was of tree limbs falling on someone because of wind or lightning. In the fall, after the Park had closed for the season and the leaves were off the trees so you could really see the limbs, we would climb up into the trees and cut the dead wood out of them to keep it from falling the next season during a storm. Sometimes even limbs that were still alive were cut to make the tree look better or to head off a limb possibly falling on a building.

What was nice about being a full-time employee is that the Harrisons would reward you for all of those seven-day workweeks by giving us seven weeks paid vacation in the winter when the Park was closed. We got a week after everything was put away, two weeks for Thanksgiving, three weeks for Christmas, then a week here and there depending on whether a new attraction was being built or something big needed to be maintained.

Gardner said, "We kept most of the animals over the winter, and they had to be taken care of, too. We built a stable behind Mount Vesuvius. We kept the deer and the lamb. Little Bo Peep had a lamb on a leash that she walked around with. By the end of the season she didn't need the leash anymore—the lamb would just follow her. Of course, the ducks just came and went with the seasons. My sister Barbara and I occasionally rode the ponies through the Park in the off-season."

Thunder storms and volcanos, paint colors and fingerprints, real lambs and fake elephants—the staff had so many details to worry about. The Selbys and the Harrisons must have done a lot of brainstorming on a regular basis to keep up. Not only did they have to be creative in their approach to telling fairy tales, but they also had to consider safety for themselves and their visitors. This was exceptionally uncharted territory at the time—who knew how to build an active volcano from scratch and keep it from hurting anyone?

Chapter 9
Out of the Ordinary

E very day was a special day at the Park, but there were also some out-of-the-ordinary events. The Park hosted raffles, concerts and contests, and sometimes Park attractions hit the road, participating in parades around the region. Imagine the delight of seeing Mother Goose making her way down busy Route 40, on her way to be featured in Baltimore's Thanksgiving Parade. Gardner said:

> *The Howard County Volunteer Fire Department used to have a carnival every year to support themselves. When they stopped having carnivals, they used to raffle off a car, and every Saturday and Sunday they would park the car in front of the Castle and sell tickets, and that's how they would make money. Harrison Shipley, who was the fire chief for the longest time, said that one year they had to call someone in Alaska who had won the car.*
>
> *One year we had a "Name the Pony Contest." Jack Wells, a Baltimore broadcaster who was well known in the 1950s as "Mr. Fortune" with his show,* Dialing for Dollars, *came out to award the prize. The kids who won named the pony "Robin Hood," which was appropriate considering the event was held at Robin Hood's Barn. The prize? The pony!*

Even during the off-season, the Park and its employees still played an active role in community events. Gardner continues:

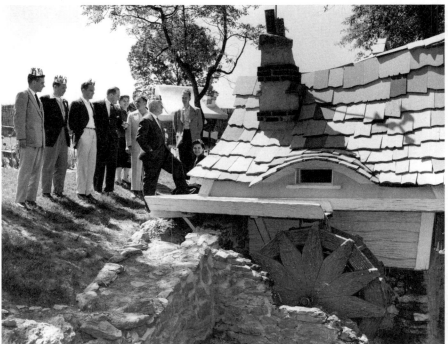

Baltimore broadcast celebrity Jack Wells joined the three brothers who won the pony in a naming contest. They named him Robin Hood. *Courtesy of Linda Harrison Gardner.*

Opposite, top: In the early years, outdoor magic shows were popular on weekends. *Courtesy of Linda Harrison Gardner.*

Opposite, bottom: Howard Adler enjoyed showing off his creations to members of the third-annual Historic Maryland tour for travel professionals and AAA counselors. *Courtesy of Linda Harrison Gardner.*

On Thanksgiving, I would don a red satin cape to become Little Red Riding Hood and motor down Route 40 behind Mother Goose to join Baltimore's Thanksgiving parade. Howard County police would escort us to the county line, and Baltimore county police would continue with us into the city. The black gosling got towed to the parade from the back of the family station wagon. The Park also participated in parades in Ellicott City and Elkridge, Maryland.

Cavey also remembers these alternative uses for the Mother Goose ride:

The Enchanted Forest used the Mother Goose ride in many parades. As a kid, I remember Uncle Bradley driving Mother Goose to parades, and they used us kids—family members, cousins—to ride in the ducks and throw out candy and literature about the Park to the people watching the parade. I remember Mother Goose being in the Lisbon Carnival parade, the Catonsville Fourth of July parade and Glen Burnie's Carnival parade. At the Glen Burnie parade, I remember seeing Mother Goose at a gas station—not getting gas, but Uncle Bradley had to rig up some headlights so they could get back to the Park. Park rides did not have lights, and this particular time they were late leaving and it got dark. Like I said before, Uncle Bradley could come up with ways to make things work. So he took some duct tape and taped lights to the sides of Mother Goose and ran some wires to the battery and home they went.

Who would have guessed that years later I'd be driving a ride in a parade? I think it was around 1973 or 1974. I got to drive the Mouse and Pumpkin Coach in a parade in Columbia. What was funny was I left the Park before 10:00 a.m. for a noon parade and just got there in time for the parade [it's about a fifteen minute ride by car]. After the parade, it was another two hours back. With this ride being as long as it was, if you went over ten miles an hour, the Pumpkin Coach would go from side to side and almost from lane to lane. A Howard County policeman rode behind me with his lights on, and he insisted that I not drive on the side of the road but stay in traffic, which got really backed up. I think most people just thought it was neat to see it out on the road so they didn't get mad at me going ten miles an hour.

My second time driving the Mice and Pumpkin Coach was in the Bicentennial parade in Ellicott City in 1976. The big thing about this was the way I had to go in the parade. I got into an area where I couldn't turn around, and we had to unhook each mouse cart and the Pumpkin Coach,

Mother Goose was the first motorized ride in the park, replacing the covered wagon. Mother Goose was fifteen feet tall. *Courtesy of Linda Harrison Gardner.*

turn them all around, and hook everything back up. I would guess that when the mice and coach were all hooked up this ride was over fifty feet long.

Tropical Storm Agnes hit Maryland on June 21, 1972. According to the Howard County Times Newspapers' *The Flood of 1972,* it was the biggest natural disaster in Howard County's history, creating the worst flooding situation ever. Over seven hundred people were left homeless due to wide-ranging flooding. Seven people died. President Nixon declared Maryland a disaster area, and Vice President Agnew toured the devastation on the East Coast. His first stop was Ellicott City. The Enchanted Forest was among the locations seriously affected by the storm.

Gardner said, "When Agnes hit, my husband and I were living on the third floor of my parents' house in the Park. We walked out into the Park and saw that the lower half was completely flooded. The floodwaters undermined Mount Vesuvius and devastated the Lighthouse. That part of the Park had to be closed while repairs were made. A couple of months later, two men

117

found a canoe nearby that they thought might be an old artifact. It was from Jungle Land."

Cavey had similar memories of the disaster:

> *The 1972 Agnes storm hit the Park pretty hard. We had replaced the entire Robinson Crusoe fort out on the island a few months before the storm hit. The island was in the middle of the lake and had a bridge that took you to Mount Vesuvius. The morning after the storm came through, I was the first one into the Park—living on the property made that easy to do. I stood outside the doors of Robin Hood's Barn, at the top of the ramp where you can overlook the playground and the Antique Cars. From there I could hear the water in the stream rushing behind the lake. I walked down toward the lake, and at the top of the hill, I could see that the fort was completely gone. The island was under about four feet of water; the tunnel in the mountain was almost under water. The Raft Ride was sitting on top of the rails that went around the pier and was only on top because it was chained loosely and had enough give to let it rise up with the water. On the other hand, Little Toot was chained tighter with no give so it was under water—all you could see was Toot's hat.*
>
> *The Jungle Land area was under water, and the jeep that pulled the carts had been under water but then was in about two feet of water. The water from that little stream that at most times we could jump across had gotten so wide and rushing that all the figures in Jungle Land that weren't made of concrete had gone down stream somewhere. The poor goat that was on the island for people to pet was gone and never to be found. This put the entire lake area out of order for some time. The only ride that wasn't affected was Alice because it was way up on the hill. Even the Lighthouse had water in it at one point during the night that was countertop high. So, just about everything either needed to be replaced or cleaned really well. When the water went down to a normal level and we could start to repair and clean things up, the mud was about two inches thick and as slippery as you can imagine.*

As in other parts of the state, the reconstruction efforts for the Park were intensive and time-consuming. However, there were some lighthearted moments as well.

> *As the repairs began, Uncle Joe and Uncle Bradley were on the island installing the logs to create a new fort. James Boszell and I were on opposite*

sides of the lake—James was on the island, and I was on the far shore. Our job was to get the logs from our side of the lake over to them on the island. We had an aluminum rowboat about six feet long, and I would guess about forty-two inches wide. I would put five or six logs that were split down the middle across the boat. The boat had one rope tied to the front and one to the back. When the boat was loaded, James would pull the boat across, unload it, and then I would pull it back.

One time, I had just loaded about six logs across the boat and was ready for James to pull it across when Buddy Harrison walked up to me and asked where Joe and Bradley were. I said they were on the island installing the logs. Now you have to picture Buddy—he's in a suit but doesn't have the jacket on. He yelled over to James to pull him over because he needed to talk to Joe. So, Buddy climbed on top of the logs, sat down with his legs crossed, and James started to pull him across. As the boat crossed we noticed that it was slowly sinking, and James started pulling the boat faster and faster but it just slowly went out of sight. I yelled at James to pull faster, and that made Uncle Joe and Uncle Bradley come out of the fort to see what was going on. What they saw was Buddy sitting on top of those logs like an Indian. By then the boat was completely under water, and the logs were starting to float away, and Buddy was still sitting there and he was up to his shoulders in water. We were all laughing and rolling on the ground, and Buddy just sat there and smiled. One thing about working there is that everyone had such a great sense of humor.

Chapter 10

₰fter Closing

I t was sad when the Park closed for the final time. Although many people organized and worked to see if it could be saved, it was not possible in its original setting. Hearing that it was closing, several people took one last nostalgic trip past the fairy tale figures, by now old friends. Sheer luck combined with great determination turned the sadness into joy that many features of the Park could be restored in a new setting at Clark's Elioak Farm and enjoyed by another generation of happy children.

Cavey recalls:

> When I realized the Enchanted Forest was going to close for good after the 1987 season, I said to my wife, "I've got to get the Park on film." I contacted my Uncle Bradley, who was manager of the Park at that time, and asked if I could come down when the Park was open and film the buildings and rides. He said, "Sure, and when you get here ask Chip Harrison to give you his keys to the buildings so you can get into them if you want too." So, one Saturday I went to the Park about an hour before it opened and started to film each building. I wanted it to be a kind of documentary more than a vacation video. So for about four hours I went around to all the buildings and rides filming them so that everyone who watched the video could see and remember what it used to be. The music you hear in the video was piped all around the Park, and there was a company who produced the tape that was used. It was something like Musictron or something like that. This was also the P.A. system for the Park that would allow for announcements to be

made, like if a ride broke down and they needed me or Uncle Bradley to come to that ride and get it up and running again or there was a lost child.

Even after the Park closed, vandalism took its toll. Robin Hood's Barn was set on fire and burned to the ground in 1990. Even though it would have been torn down when the shopping center was built, the worst thing about it was that everything that was in the barn was lost forever—irreplaceable papers in the office were destroyed. The Chicken Little show in the basement of the Barn was lost. When the Park was operational, Robin Hood's Barn was where we stored figures during the winter months. Luckily, because the barn was going to be torn down, the figures were not stored in the barn as usual and were not lost in the fire.

According to former fire chief B.H. Shipley Jr. in his pictorial history of Ellicott City and its fire department, *Remembrances of Passing Days*, "Perhaps the most disheartening case of arson occurred Friday, January 5, 1990, when fire swept through the grounds of the thirty-two acre Enchanted Forest Amusement Park...Its original owners had sold the park to a development group less than twelve months earlier...The fire destroyed most of the two-story building known as Robin Hood's Barn, which housed the Park's snack bar and gift shop. Police subsequently arrested three Baltimore County teenagers and charged them with trespassing, theft and malicious burning."

Gardner talked about the two homes she knew as a child. Of the Belgian Village, she said, "It's no longer there. It's just a vacant field now. I've often thought that if I was ever a grandmother I would never be able to show my grandchildren where I grew up—either place—because our house in the Enchanted Forest is gone now too."

In 1988, the Harrison Family sold the Park for $4.5 million to JHP Development, a Towson, Maryland firm. JHP closed the Park in 1989 (it was briefly open in the summer of 1994, mostly for children's parties), and the Park was left to the elements. Mid-Atlantic Realty bought the property in 1997, and Kimco Realty Inc. bought Mid-Atlantic in 2003.

The Park has lived on in people's memories and makes occasional appearances in the media. In 1990, the Park was featured in the John Waters movie *Cry-Baby*, starring Johnny Depp and Ricki Lake. In 1995, the Park was used in a backdrop for an episode of *Homicide: Life on the Street*, featuring Lily Tomlin. Author Laura Lippman features many venues in the Baltimore/Washington area in her novels. The Enchanted Forest was mentioned in both *What the Dead Know* and *In Big Trouble*. Author Mary Downing Hahn sets her novel *Closed for the Season* in a lightly veiled version

of the Enchanted Forest called the Magic Forest. Even *Zippy the Pinhead*, the comic strip character written by Bill Griffith, visited the Enchanted Forest after it closed and called it a "relic of the distant past...a magical time before the invention of the Sony Play Station or Mortal Combat." *The Baltimore Sun Magazine* on May 12, 2013, featured "Fifty Objects that Define the City of Baltimore," described as "key components of what makes living in these parts special." The Enchanted Forest, described as "a favored destination for young children," is listed, along with the fact that "the park's magic continues" at Clark's Elioak Farm.

Chapter 11

\mathcal{A} \mathcal{N}ew Home and a \mathcal{N}ew Life for the Enchanted Forest

In 2004, Martha Clark, of Clark's Elioak Farm, came along to pick up the pieces. The Clark family has been farming in Howard County since 1797. Her father, James Clark Jr., raised Angus cattle and ran a dairy operation on the farm for forty years, starting in 1946. In the 1980s, he placed the parcel in agricultural preservation. Eventually, Martha's brother Mark took over the dairy operation and expanded it with a move to Georgia in the early 1990s. From that time until around 2006, the farm concentrated on crops and beef. In the meantime, Martha had worked with her husband, Doug Crist, running the Farm and Home Service store in Ellicott City. After Doug's death in 2000, Martha sold the business and returned to the farm with the idea of starting a petting farm on part of it.

Clark said, "In March of 2002, I read in the *Baltimore Sun* that the Cider Mill petting farm in Elkridge was being sold. I saw this as an opportunity to fill a void that was being created. There would be nothing else similar in the area. So I got to work and with the help of family and friends, we opened the petting farm in the fall of 2002. In the beginning, we had goats, sheep, pigs, donkeys, horses, ponies, chickens, peacocks, turkeys, ducks and rabbits. In addition to the petting farm, there is a pumpkin patch, hayrides, pony rides, picnic areas and a general store. School tours and birthday parties have been hosted on the farm since we opened up in 2002."

Meanwhile, the attractions at the Enchanted Forest languished. Interested individuals formed groups to try to save the Park. The Friends of the Enchanted Forest was followed by the Enchanted Forest Preservation

Society. Neither was able to raise the funds necessary to revive the Park. In 2003, the Howard County Historical Society displayed an exhibit of photographs, maps and brochures related to the Park that was one of the most popular attractions at the Howard County Fair and renewed interest in its well-being. The Enchanted Forest site is also listed on the Howard County Historic Sites Inventory.

Meredith Peruzzi is one of the people devoted to maintaining the memory of the Park on Facebook. She said:

> I grew up in Columbia, and the Enchanted Forest was always a presence for me just across town. I have been interested in history my whole life, and I always missed the Park. Having it so close and yet untouchable was always sad for me, and it was this that led me to form the Enchanted Forest Preservation Society in 2003. Of course, with half the Park erased by the shopping center, it could never be what it once was—which is why Martha Clark's restoration, beginning in 2005, has been so important. Although I regularly receive inquiries through the EFPS website about visiting the Park itself for photography, filming, etc.—inquiries I always direct to the Kimco property manager—it is the Clark's Elioak Farm project that has been the most vital legacy of the Enchanted Forest. The Park itself is no longer useful; despite the existence of Cinderella's Castle and some of the other larger structures, it will never be home to children again. But Clark's Elioak Farm brings the magic we grew up with to our children today!

In 2004, Preservation Howard County put the Park on its list of ten most endangered historic sites in Howard County. The group's president, Fred Dorsey, said, "PHC placed the Enchanted Forest on our endangered list in 2005 to recognize its importance as a recreation icon in Howard County, the work being done to move, restore and preserve its structures and to give visibility to the need for funds to complete the transition to the Clark's Elioak Farm." The group hoped that the attractions could be moved to a new location and put on display for the public. A group called the Enchanted Forest Preservation Society formed to lobby for the Park's reopening on site but was unable to raise the funds necessary for this to happen. The county's planning department discouraged the on-site revival proposal, noting the heavy traffic on Route 40, the lack of adequate parking and the fact that much of the Park is a wetlands area.

Martha Clark was following the fate of the Pumpkin Coach with interest. Since she was developing a petting farm on her property, she thought that

some of the Enchanted Forest attractions might find a home there as well. Clark said:

> *Debbie Burchardt was a realtor with Coldwell Banker, whose office was located at the Enchanted Forest Shopping Center. In 2004, she was looking for something to offer for a realtor's charity auction. The auction raises money for local food banks and other causes. She noticed Cinderella's Pumpkin Coach outside the gates of the Park, behind Petco, which gave her the idea of asking the property owners, Kimco Realty of New Hyde Park, New York, for something from the Park to raffle off. She was thinking something small, like a door. Instead they gave her the Pumpkin Coach, which was in terrible shape. The company wanted it moved because it was outside the gates of the Park and accessible to vandalism. Debbie learned to work with fiberglass to restore the Coach. She contacted Mark Cline, an expert on fiberglass construction, and got advice from him. She and other volunteers spent two months restoring the Coach. The restored Coach and a sign from the Park were auctioned off at the Howard County Fairgrounds on June 29, 2004 for $2,300.*

Even after the Park closed, Norm Cavey held it close to his heart. He seized any opportunity that arose for him to help preserve it. Cavey said:

> *One day I got a phone call from a longtime friend, Danny Lennon. He worked as a real estate agent for Debbie Burchardt. Danny said I was going to get a call from Debbie as she had some questions about the Pumpkin Coach and would it be alright. I said sure. Debbie called and wanted to know if I knew anything about how the Coach was constructed. I said, "Yes, I think so, because I helped build it." We decided to meet one afternoon at her office. When you went out the back door of her building, within a few feet was the Pumpkin Coach just sitting there. The paint was peeling off, the tires were flat, and the leaves that were used to hide the tires were lying inside the Coach, and the material on the seats was all torn up. She asked me what materials were used to build it, because she didn't want to sand on something that might have asbestos in it. I told her the story about the cement and the fiberglass to help hold down the weight of the ride and told her there was nothing to worry about.*
>
> *Debbie's reason for restoring the Pumpkin Coach was to raise money for different charities their company was associated with. Every year they would invite their clients to a party and silent auction at the Howard*

County Fairgrounds. She was hoping someone would buy the Coach and use it at a daycare or something like that, so kids could play in it. Well, it was sold, but in a short period of time it was seen on eBay—and that's where Martha comes into the story.

Essex, Maryland business partners Elby Proffitt and Scott Shephard bought the Coach with the idea of showing it in local parades, although two local Fourth of July parades rejected it. They stored it in Shephard's garage in Middle River and eventually listed it for sale on eBay. Fortunately for all, they received no bids.

Clark said:

When I read about this, I contacted them and told them that my farm would be the best place for the Coach to be. They were also approached by a landscape company and a car dealer but eventually agreed with me that I was right. They sold it to me, and on August 18, 2004, I drove to Middle River and put it on the back of a flatbed truck and drove it back around the Baltimore Beltway to my farm. Finally the Pumpkin Coach would have a safe home where others could see and enjoy it.

The farm opened for its fall season on September 12 that year, with the Pumpkin Coach on display for the first time. We had the Coach open, and kids could climb in and out through the windows. In the course of the season, they wore away the fiberglass on the windowsills. For the next year, we closed the Coach and put the Prince inside trying the glass slipper on Cinderella.

After the success of the first season having the Pumpkin Coach, Clark thought that her farm would be a great place for more of the Enchanted Forest attractions. So she approached Kevin Allen at Kimco Realty.

He vetted me and was assured that the pieces would be going to a good home. However, he asked that I take them all, rather than just taking a few of them. The generosity of Kimco Realty in giving the pieces to me was key to making the preservation and restoration of the attractions at the Park a reality. Working with Kevin Allen and other Kimco employees over the eight years of moving the pieces to Clark's Elioak Farm has been an excellent experience.

We started moving the pieces that first winter of 2004–05, with the help of Len Busso of Cross Country Builders. They were the original rides that were made of fiberglass, not concrete, so they were lighter and not attached to the ground. There had been some changes made to the original

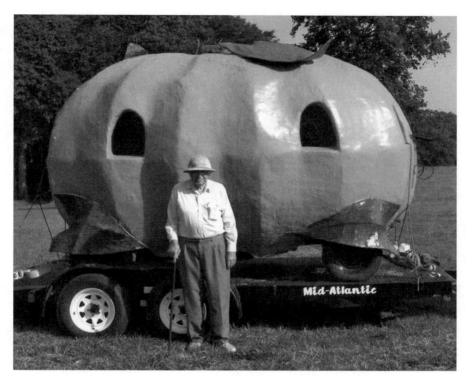

Senator James Clark, with the Pumpkin Coach that started the rescue and move to Clark's Elioak Farm of many features from the park. *Courtesy of Martha Anne Clark.*

pieces—Mother Goose and some of the mice were slides, and other mice had been turned into picnic tables. The White Goslings and the Black Duckling didn't have seats anymore, they were just regular animals. Once we got the pieces to the farm, we had to restore them.

That winter, I learned how to fiberglass. I worked in our education building, keeping the room warm with a propane heater while I made repairs to Mother Goose and the mice. Just like the staff of the Enchanted Forest had done since 1955, we had to do the repair and painting work during the winter when conditions were never good. And as we have learned throughout the years since 2004, there is a tremendous amount of work to keep everything looking good. Already some things are ready for their third repainting. We are fortunate that Clark's ACE Hardware has donated all of the Benjamin Moore paint we have used since we started in 2004.

Marty Levine and his crew from Ex-Cel Tree Experts used his amazing crane and formidable equipment to move the Lil Red Schoolhouse, the

Martha Clark learned to work with fiberglass and restored and painted many of the attractions herself. *Courtesy of Martha Anne Clark.*

Crooked House, Willie the Whale and the Rainbow Bridge, among other items. They also worked with Expert House Movers to bring the Easter Egg House, the Three Pigs Brick House, the Three Bear's House and the Old Woman's Shoe to the farm.

Some attractions, like the Shoe, at twenty-three feet tall and thirty thousand pounds, required more than a little resourcefulness to move. For even the short ride from the original Park, down Centennial Lane to Route 108 and the farm, we realized that the Shoe was too tall to fit under the electric and phone lines. So we had to cut the shoe in half and bring the top and the bottom on separate trailers to the farm. We also had to cut the Three Bear's House into two sections and bring it on separate trailers. Putting them back together was equally challenging.

In an editorial published on February 13, 2005, the *Baltimore Sun* called Martha Clark "this tale's fairy godmother" and praised her efforts to keep parts of the Enchanted Forest in Howard County, available for making new childhood memories. In turn, Martha Clark calls Debbie Burchardt her fairy godmother. Clark said, "If it weren't for Debbie repairing and auctioning off the Pumpkin Coach, none of the rest of this amazing adventure would have happened."

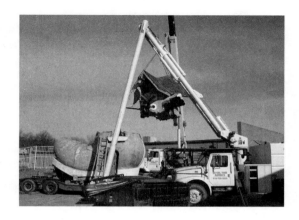

The shoe had to be cut in half to avoid power lines in order to move it from the Enchanted Forest to Clark's Elioak Farm. *Courtesy of Martha Anne Clark.*

Clark continued:

> *It was exhilarating, fun and challenging to move things from the Enchanted Forest. Some of the houses were on foundations, and we had to figure out how to move them without destroying them. We had to get a large crane, trailers and other equipment onto the narrow paths of the Park in all sorts of weather. Ex-Cel Tree Experts and Expert House Movers were amazing partners in this endeavor. George Miller, of the George Miller Construction Company in Catonsville, also helped throughout our years of moving attractions. He donated and built the wall that Humpty Dumpty sits on. He also put both the Shoe and the Three Bears' House back together once they were on the farm. S&K Roofing donated two new roofs. In 2005, the Hampton Hotel chain invited us to apply for their Save-A-Landmark Program that offered funds and volunteer support to a historic roadside attraction in each state. We received $32,000 and forty volunteers—staff from the local Hampton Hotel—for a day. Howard Bank and Coldwell Banker Realty also made significant contributions.*

Volunteers, including Monica McNew-Metzger, have assisted with the restoration of many of the figures, but for the big jobs, Clark brings in Mark Cline, who owns Enchanted Castle Studios in Natural Bridge, Virginia. Cline creates figures for a variety of attractions, including Six Flags and Dutch Wonderland, and has been a lifelong fan of the Enchanted Forest. Cline uses fiberglass to create his figures, rather than the old way of frames covered with cement.

> *I owe a lot of what I do today by having been lucky enough to have been a child who visited the Enchanted Forest many times in its 1960s heyday! A*

local newspaper compared me to a "young prince who returned many years later to save the kingdom that had fallen into ruin." Another paper called me a knight that returned from a quest to save his beloved kingdom that had "spawned" him.

Honestly, the Enchanted Forest did have a major impact on my young life and I identified the figures themselves as old friends. To be able to come back and give them new life was one of my favorite projects of all time…and I have done many projects worldwide in my professional career over thirty years. When one of the three pigs was missing, I was able to recreate him from old photos to match the style and look as he looked before. I was able to do many of the figures or recreate missing parts by using some old black and white photos of me and my brothers frolicking around the actual pieces. I remember riding on Mother Goose and trying to figure out how it was made, what was the designer thinking when he created it, what was underneath? When it came time to recreate the Tortoise we could find only one photo of his face, and had to work from that.

The experiences at the Enchanted Forest shaped my life to the point where I was inspired to draw from my adventures there and share them with other kids back in Virginia. In the back of my mind I somehow refused to believe that when you grew up you wouldn't have your own castle or be the hero of your own adventure. My inspired comics and drawings lead me to creating papier-mâché figures, the natural progression from 2D to 3D. From there, I learned how to create more permanent sculptures using fiberglass. With my fiberglass creations, I opened my first attraction in Natural Bridge, Virginia. This became the Enchanted Castle Studios, a name which was also inspired by the Enchanted Forest. The studio itself was designed to look like a castle. I wanted to prove to myself I could grow up and have my own castle and I didn't let myself down. Today, in great part due to my few visits at the Enchanted Forest, I now create fantasy figures for many theme parks and attractions worldwide. While I work with people all over the world, I really love the jobs like this that come from the heart.

Monica McNew-Metzger is another Facebook friend of the Park. An accomplished painter, she has helped restore several of the attractions that now grace Clark's Elioak Farm. She said:

My memories of the Enchanted Forest are very vivid. In an instant, I am transported back there again. I went to the Park in both elementary school and junior high and on family trips as well. My mom was always sure to

tell any new families that moved into our neighborhood about the Enchanted Forest, and we would all go and make a day of it. I know that my love of children's storybooks and fairy tales, and my love of art, were inspired by the Enchanted Forest. I became an artist when I grew up.

My most favorite places in the Enchanted Forest were Rapunzel, Sleeping Beauty, Alice in Wonderland, and, of course, Willie the Whale. One of my most favorite memories is from the Alice in Wonderland attraction. It involves seeing Alice falling down the rabbit hole in the tree trunk in the picnic area above the tunnels and then riding in one of the tea cups that go through the tunnel and seeing Alice coming towards me, as she is falling down the rabbit hole.

I went back when I was in college, when I had heard that the Enchanted Forest was being sold. I wanted to see my favorite place again, and I'm so glad I did. I remember seeing Alice again when I came back to visit the Enchanted Forest and feeling very emotional as I saw my old friend again. Visiting the Enchanted Forest felt like coming back home again.

Later when I got married and had my own child, I wanted to take her to see the place that I loved so much and share the enchantment with her. That is when I found that it was closed. I started asking around about what had happened, and what might happen in the future, to my beloved Enchanted Forest. I found a post online by Meredith Peruzzi where she talked about wanting to save the Enchanted Forest too. Her blog post had a lot of comments from lots of people wishing the same thing, so she created an online group called the Enchanted Forest Preservation Society. I joined the group, along with many others, and attended several Howard County meetings to see how I might be able to help.

Later still, after Martha Clark and her family stepped up and were able to work something out to save what was left of the Park, I offered my talents as an artist, to help in whatever way I could. Debbie Burchardt, who had been instrumental in helping in the effort, was trying to do something with some of the stones that came from a wall that surrounded Cinderella's Castle. I offered to try painting favorite Enchanted Forest themes on them, and then they were auctioned off to raise money needed for relocation and restoration of the pieces that came from the Enchanted Forest and were moved over to Clark's Elioak Farm. Martha also asked me to do a mural of the map of the original Enchanted Forest, like the paintings I had done on the stones.

The stones are among the popular and charming souvenirs for sale at the Farm. At the authors' request, Monica also painted the lovely scene used on the cover of this book. McNew-Metzger continued:

I was also able to help with some of the restorations, and my first project was the giant Happy Birthday Cake that used to sit inside of the Gingerbread House. The project ended up being a family one. My husband, Joel Metzger, was able to repair a large crack that ran the entire length and down the sides of it, as well as recreate the cement forget-me-nots that adorn the edge of the cake. My young daughter, Jennifer, helped prime and paint the cake. And I was able to recreate the roses and letters that spell out "Happy Birthday" on the top of the cake. The only reference we had to what the original cake looked like was a special birthday photo loaned by Enchanted Forest Preservation Society member Stephanie Hopkins-Reba and the faint outline of where the decorations used to be. We were able to restore the Happy Birthday Cake and return it to Clark's Elioak Farm. My parents even got in on the act, helping to transport the heavy cake. The cake was made of cement, about an inch or so thick, over a metal frame covered in a metal mesh. It took about five or so of us to move the cake from the van to the table that sits in the gazebo at the farm. The best part of the project was working with my family and that Stephanie was able to visit the farm and take a next-generation photo of the Birthday Cake with her own child. It is photos like Stephanie's that have made restoration possible, and working with others to bring these beloved pieces back to life has been one of the greatest gifts.

Since that first project, Martha has asked me to restore a few other pieces, some of which I have had in my basement—it's still so surreal. I mean, who would have ever thought! The last project I completed was restoring a Card Guard from Alice in Wonderland that had been lovingly saved by Bob Bretz. It's been so wonderful to see that because of the love of the Enchanted Forest over the years, many people saved figures in their private collections, and they have now made their way back to the farm so generations can enjoy the enchantment once more.

I have had the absolute blessing of being able to meet some of the incredible Harrison family, and Clark family, as well as the wonderful people who worked there at the Enchanted Forest and all those who continue to work together to carry on this enchanted dream, where ALL children are celebrated! I think what I come away with is what the Enchanted Forest gave me and continues to give to me: a love for these beautiful children's stories, some beautiful memories, my love for art and that "full circle" of giving back to a place that gave me so much.

Stephanie Hopkins-Reba is another fan of the Enchanted Forest who loves to share her memories. She said:

> *I have a photograph of me sitting on the Birthday Cake. I was two years old, sitting up on it with Little Red Riding Hood. They were able to recreate it (at Clark's Elioak Farm) using my photo. I am very nostalgic and have such a passion for all things Enchanted Forest–related. I remember so much. I clearly even remember the musty smell in Alice in Wonderland. Underground, there was a bridge, and it had water with neon-painted walls where water flowed. I also remember sitting in Robin Hood's Barn eating an order of curly fries! There is a photo online somewhere of Doo Bee from* Romper Room *holding me. This had to be on my birthday, the same day I had my party there. I remember my mom sliding with me on the mountain slide. I would always also get a snowcone—the rainbow ones, and of course they always would drip on me! I still have an Enchanted Forest leather wallet. Enchanted Forest was simple. These days, children cannot fully appreciate the simple things, due to all the computer-animated movies and video games. It breaks my heart that I couldn't share the Enchanted Forest with my children. I am thankful though that Clark's Elioak Farm has given people the opportunity to experience the Enchanted Forest again, although it will never be the same as the original.*

Clark said, "On August 14, 2005, we celebrated the fiftieth anniversary of the opening of the Enchanted Forest. Howard County Executive James Robey conducted the event's opening ceremony. Robey himself worked at the Enchanted Forest as a teenager." Gardner said, "I asked him what he did there. He remembered the experience fondly and answered that he mostly picked up trash." Governor Robert Ehrlich attended the event and issued a proclamation celebrating the fifty-year history of the Enchanted Forest.

The Park's magic continues to appeal to a broad spectrum of people. In early 2013, the Howard Peter Rawlings Conservatory and Botanic Garden of Baltimore, located in Druid Hill Park, celebrated its 125th anniversary with a special flower exhibit featuring many of the Enchanted Forest's iconic characters, including Willie the Whale; Hickory, Dickory, Dock; and the Rainbow Bridge, among the spring flowers. Clark's Elioak Farm assisted in this presentation.

Clark says, "My goal was never to become the Enchanted Forest. My goal from the very beginning has been as a preservation effort. We are proud of our work in restoring and maintaining many of the original Enchanted Forest

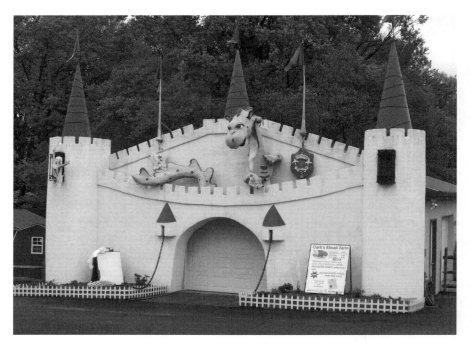

The dragon welcomes visitors to the castle entrance at Clark's Elioak Farm today. *Courtesy of Martha Anne Clark.*

attractions and characters at Clark's Elioak Farm. We welcome a whole new generation of families to explore the wonder and magic of the Enchanted Forest and delight in the opportunity we offer Enchanted Forest visitors from an earlier time to relive a bit of their past and revisit their favorite characters and attractions from a bygone era. My debt of gratitude to the Harrison family is reinforced everyday by visitors to the farm who regale me with their favorite memories of their visits to the Enchanted Forest—the magic of the Enchanted Forest lives on—hopefully for a long time to come."

Selected References

Clark, James, Jr. *Jim Clark: Soldier, Farmer, Legislator.* Baltimore, MD: Gateway Press, 1999.

Cramm, Joetta. *A Pictorial History Howard County.* Norfolk, VA: The Donning Company, 1987.

Hafner, Allen B., Jr. *Howard County Police Department, 50ᵗʰ Anniversary Commemorative Album.* N.p: privately published, 2002.

Kusterer, Janet, and Victoria Goeller. *Remembering Ellicott City.* Charleston, SC: The History Press, 2009.

Mariani, Theodore. *Impact of Columbia on the Growth and Development of Howard County Maryland.* Woodbine, MD: privately published, 2011.

Shipley, R.H. *Remembrances of Passing Days.* Virginia Beach, VA: The Donning Company, 1997.

Times Newspapers. *The Flood of 1972.* Ellicott City, MD: Times Newspapers, 1972.

Index

About the Authors

Janet Kusterer earned her master's degree from Johns Hopkins University. She is an author of four books of local history. She is a past president and past executive director of Historic Ellicott City, Inc, and she is on the board of the Ellicott City Restoration Foundation. Ms. Kusterer is a member of the Howard County Historical Society, and edits its newsletter. She writes a neighborhood column called "Mostly Main Street" focusing on the historic district of Ellicott City for the *Howard County Times*.

Martha Anne Clark owns Clark's Elioak Farm, a petting farm in Howard County, Maryland. She has spent the last eight years moving the attractions from the Enchanted Forest to her farm so that they may be enjoyed by another generation of families and children in Maryland. Her visits to the Enchanted Forest as a child inspired her to "preserve" this landmark. A graduate of Duke University, Ms. Clark is a lifetime member of the Howard County Historical Society, a founding member of Preservation Howard County and a past president of the Howard County Tourism Council.

Visit us at
www.historypress.net
..
This title is also available as an e-book